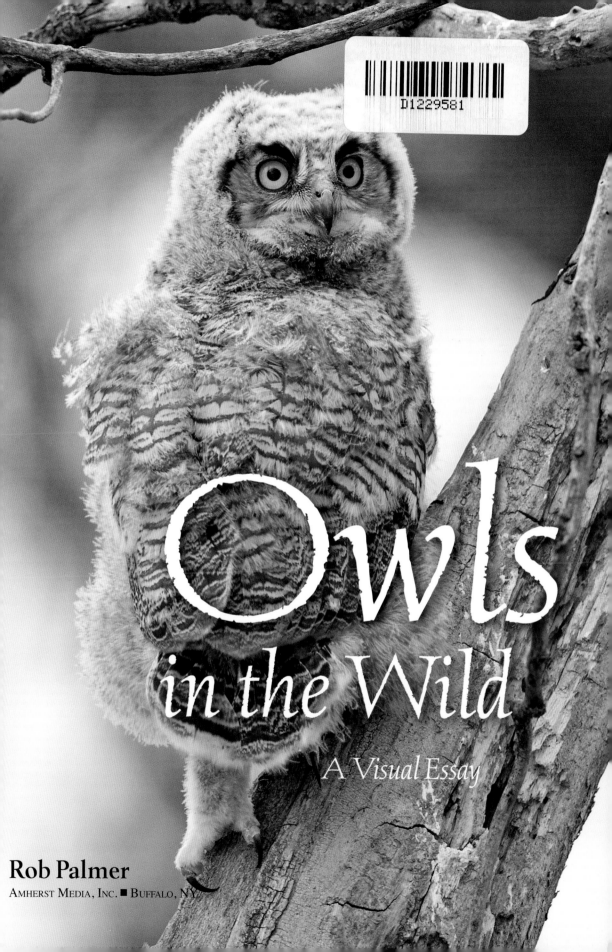

Owls
in the Wild

A Visual Essay

Rob Palmer

AMHERST MEDIA, INC. ■ BUFFALO, NY

Published by:
Amherst Media, Inc., P.O. Box 538, Buffalo, N.Y. 14213
www.AmherstMedia.com

Publisher: Craig Alesse
Senior Editor/Production Manager: Michelle Perkins
Editors: Barbara A. Lynch-Johnt, Beth Alesse
Acquisitions Editor: Harvey Goldstein
Associate Publisher: Katie Kiss
Editorial Assistance from: Carey A. Miller, Rebecca Rudell, Jen Sexton-Riley
Business Manager: Sarah Loder
Marketing Associate: Tonya Flickinger

ISBN-13: 978-1-68203-334-0
Library of Congress Control Number: 2017963169
Printed in The United States of America.
10 9 8 7 6 5 4 3 2 1

www.facebook.com/AmherstMediaInc
www.youtube.com/AmherstMedia
www.twitter.com/AmherstMedia

AUTHOR A BOOK WITH AMHERST MEDIA!

Are you an accomplished photographer with devoted fans? Consider authoring a book with us and share your quality images and wisdom with your fans. It's a great way to build your business and brand through a high-quality, full-color printed book sold worldwide. Our experienced team makes it easy and rewarding for each book sold—no cost to you. E-mail **submissions@amherstmedia.com** today!

Contents

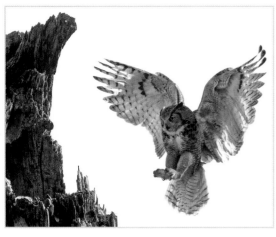

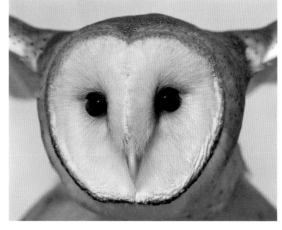

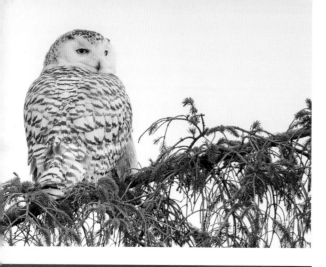

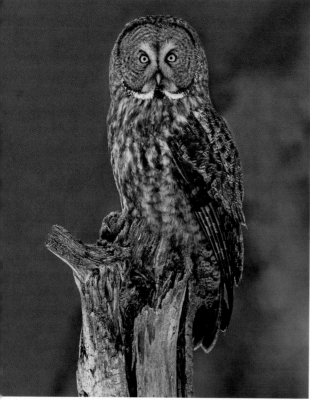

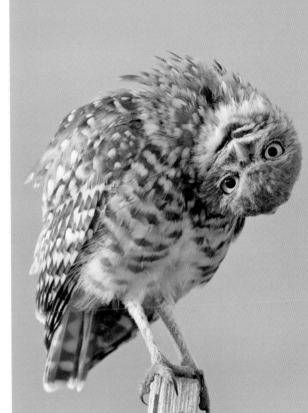

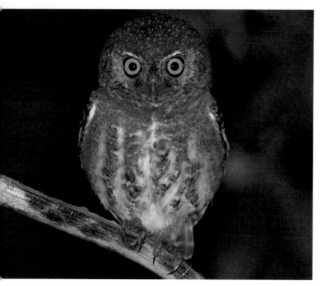

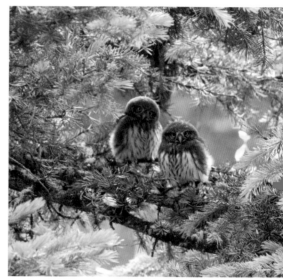

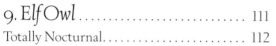
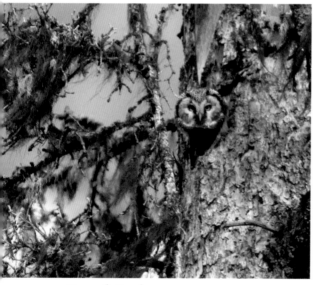

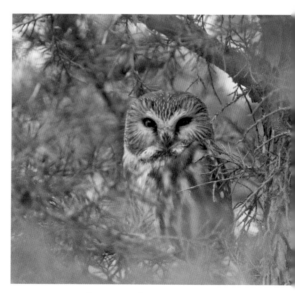

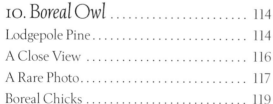
this page: bottom left (boreal owl), top right (pygmy owl)—Photographs by Dan Hartman.

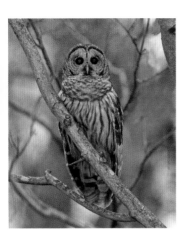

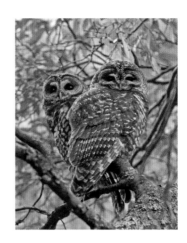

About the Author

Naturalist

Rob Palmer has been involved with animals since he was very young. He has always had a passion for birds of prey, and has pursued that passion throughout his adult life. In college, he spent numerous hours studying the nesting territories of prairie falcons in Northeastern Colorado and additional time researching screech owls nesting along the Boulder Creek trail in the center of Boulder, Colorado.

Photographer

Rob began taking pictures with a Polaroid black & white camera when he was twelve, then quickly moved on to a 35mm SLR. His first SLR was a Kowa. In high school, he became the school's photographer and was able to use the school's Pentax cameras. The basics in photography have stuck with him.

Teacher

Rob has also been a teacher all his life. He taught secondary school biology for ten years and outdoor education over the years. He now teaches photography both outdoors and inside the classroom.

Awards & Publication

2005: *Mating Avocets.* Winner, Birds Category, *National Wildlife Magazine,* back cover.

2005: *Goldeneye and Ducklings.* Winner, Birds Category, *Wild Bird Magazine.*

2006: *Swift Fox with Kangaroo Rat.* Winner, Animal Behavior, *National Wildlife Magazine.*

2007: *Pronghorn Jumping.* Grand Prize Winner, Wildlife Photographer of the Year, *National Wildlife Magazine.*

2007/2008: *Hovering Kestrel.* Winner, Birds Category, *National Wildlife Magazine.*

2008: *Battling Eagles.* Image of the Year, Photographic Society of America.

2009: *Eagle and Blackbird.* BBC Wildlife Photographer of the Year Winner Bird Behavior Category.

2009: *Eagle and Starling.* Winner, Birds Category, *National Wildlife Magazine.*

2011: *Burrowing Owlets and Prairie Chickens. Nature's Best Magazine* Highly Honored Images.

2011: *Battling Eagles.* Grand Prize, *Audubon Magazine* front cover.

2012: *Dancing Prairie Dog. Nature's Best Magazine* Highly Honored image.

2013: *Preening Kestrel. Nature's Best Magazine,* Highly Honored image, Art in Nature Category.

2013: *Nature's Best Magazine,* Vole and Coyote 3rd Place professional.

Rob's images have also been featured on the covers of *Birders World, Living Bird, American Falconry,* and *National Wildlife.*

Contact

http://www.falconphotos.com

1. Great Horned Owl

The great horned owl *(Bubo virginianus)* is the most common owl of North America. It can be found from Alaska to Mexico and California to Maine. They are mostly nocturnal in their habits, although they can be seen any time of day—especially in the early morning or late evening.

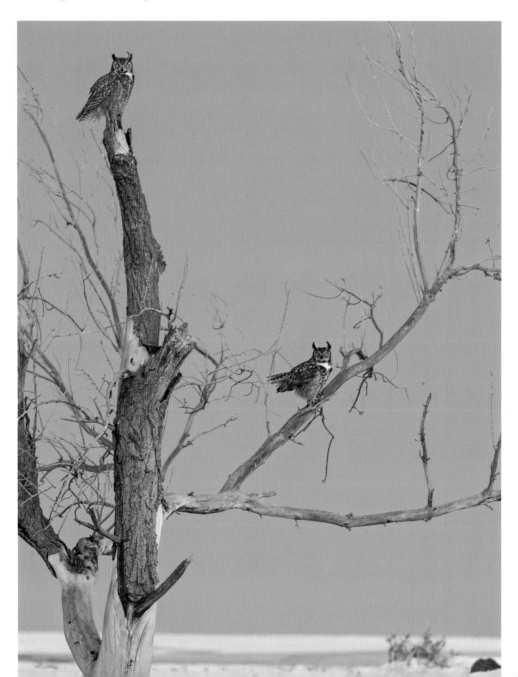

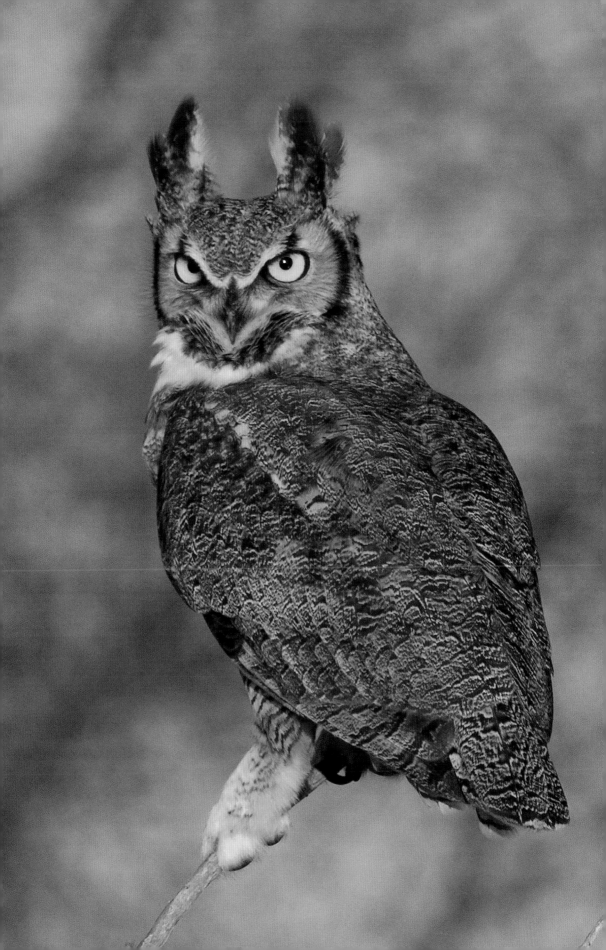

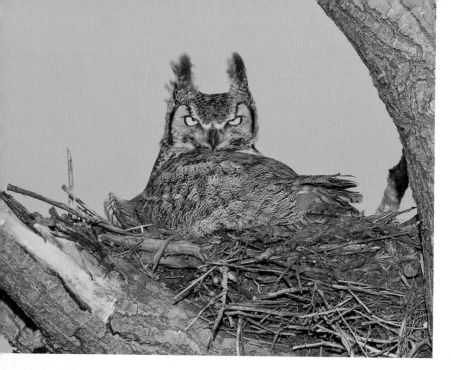

Nesting

left—A female sitting on her eggs in an abandoned hawks' nest *(left)*. Great horned owls do not make their own nests. They either use other birds' nests (such as those of hawks, crows, and magpies) or hollows in trees or cliffs—anywhere they can find a suitable platform.

below—An owl nesting in a hollow tree.

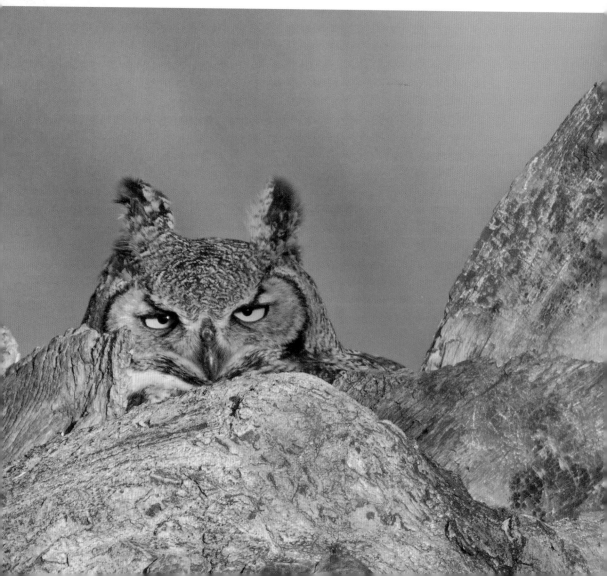

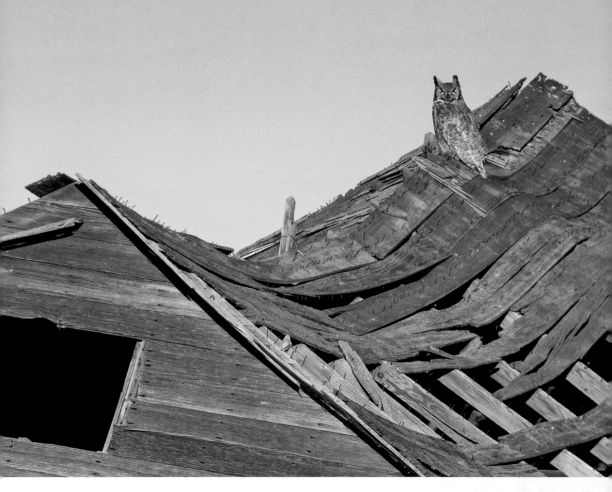

Abandoned Places

above—An owl sitting atop an abandoned farmhouse.

right—Many of the nest areas I find out in the plains are in abandoned farm areas like this one.

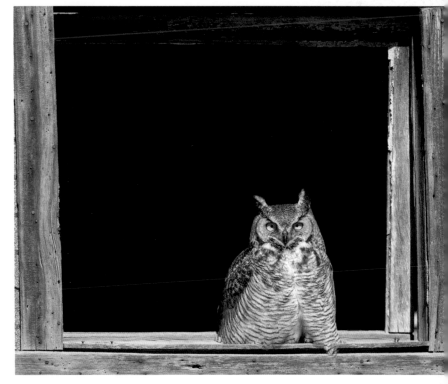

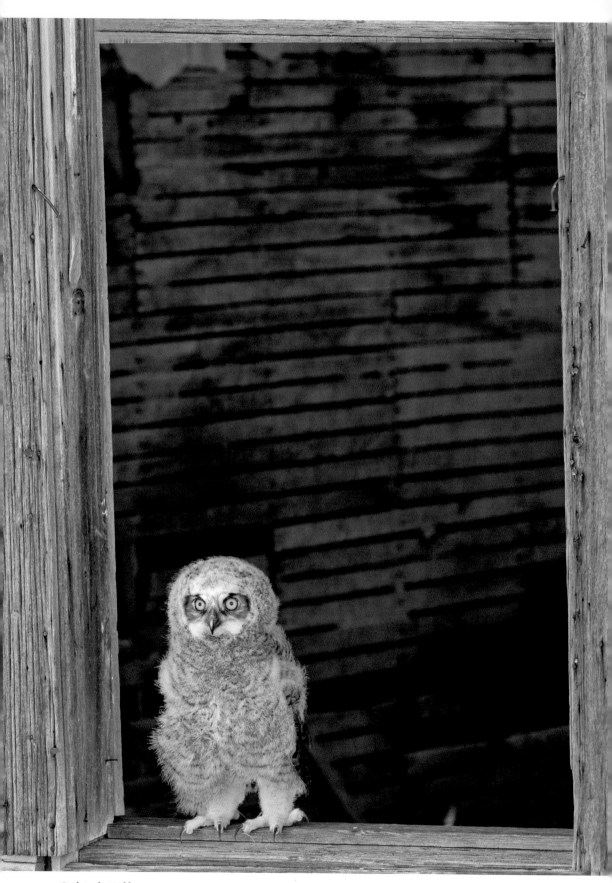

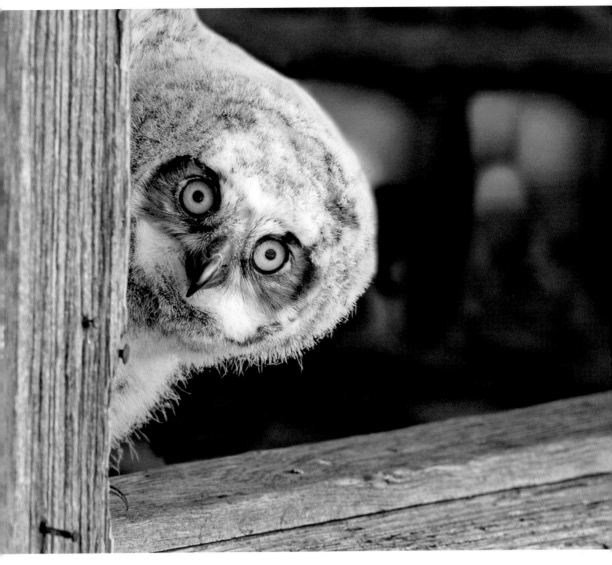

Owlets

facing page—On the other side of the farmhouse was a young owlet, about five weeks old.

above—The same owlet peering around the corner. This bird is about two weeks from being able to fly.

right—The same owlet with his sibling up in the attic of the abandoned farmhouse.

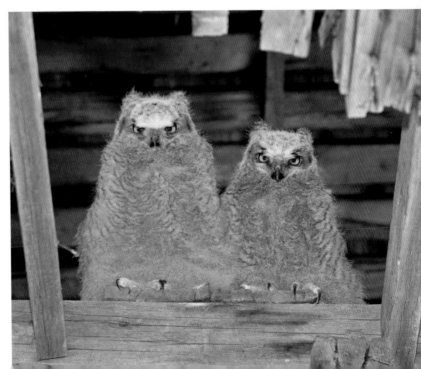

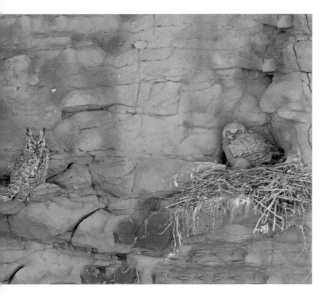

Nesting Everywhere

above and facing page—These owls have chosen an abandoned red-tailed hawk nest on a cliff to raise their youngster.

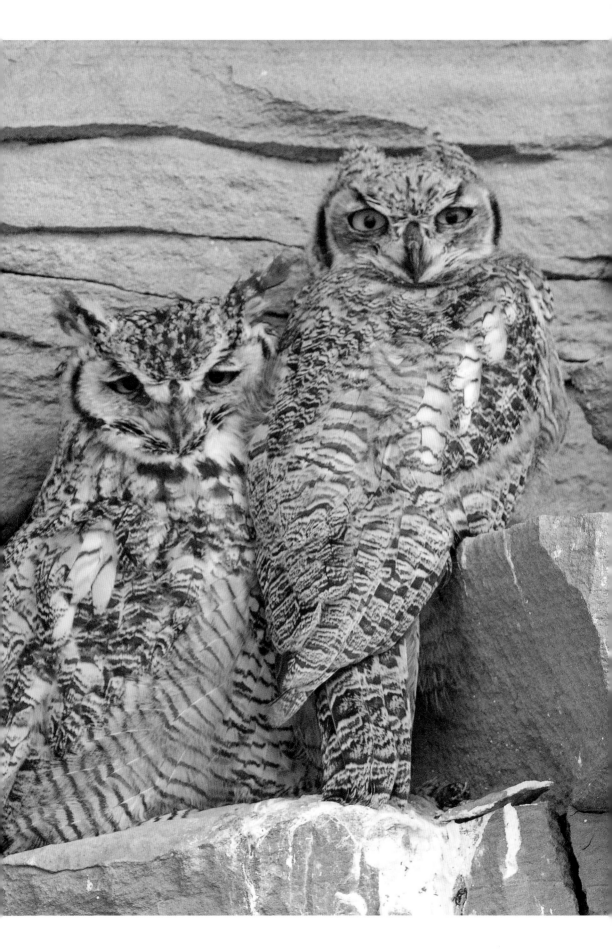

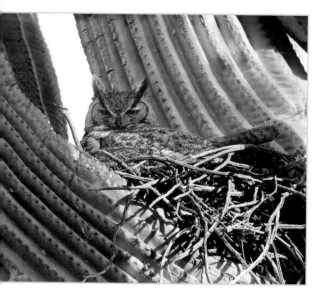

above—This owl used a nest in a saguaro cactus. The nest was probably made, originally, by a hawk or raven.

right—This nest is in a space that was created by a broken off tree limb. You can see the little two-week-old owlet on the bottom right.

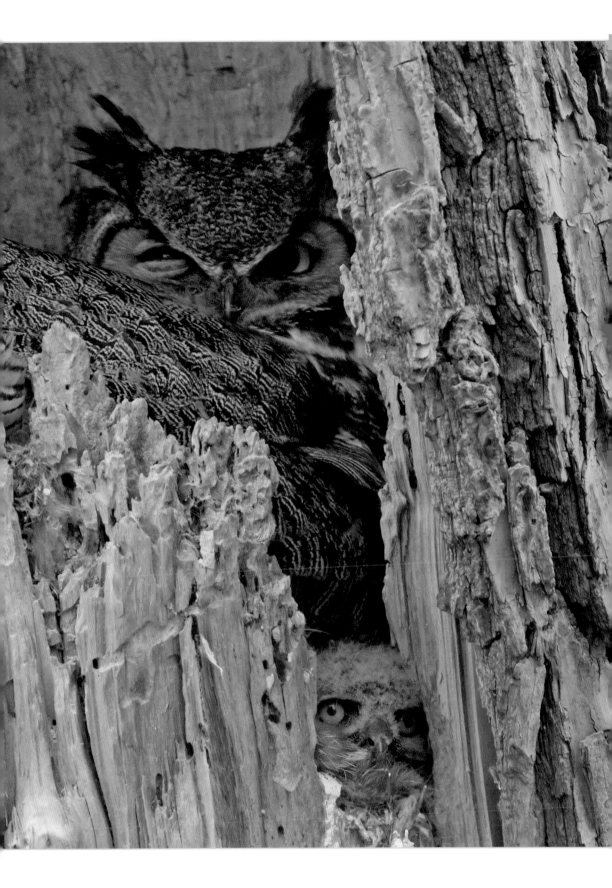

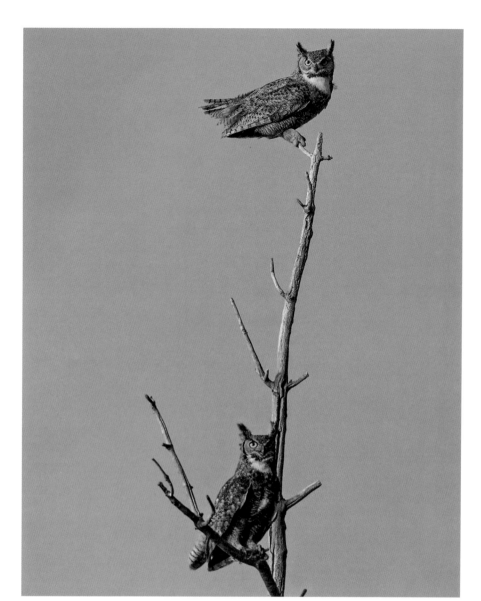

Protecting the Nest

left—Great horned owls are very protective of their nests. Both the male and female will sit in a nearby tree and let you know you are too close to their nest.

Mating Rituals

facing page, top—Great horned owls nest very early in the year, starting their mating rituals as early as January—when it can be cold and snowy. In Colorado, they usually lay their eggs in late January or early February. This image shows a mating posture of one of the adults.

facing page, bottom—Another photo showing the mating posture of a male great horned owl.

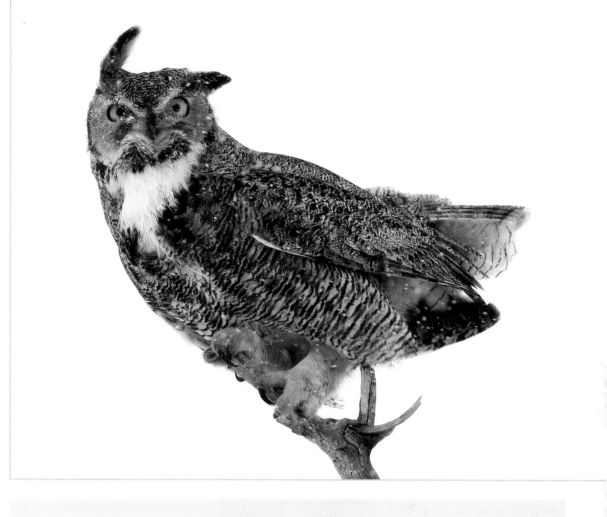

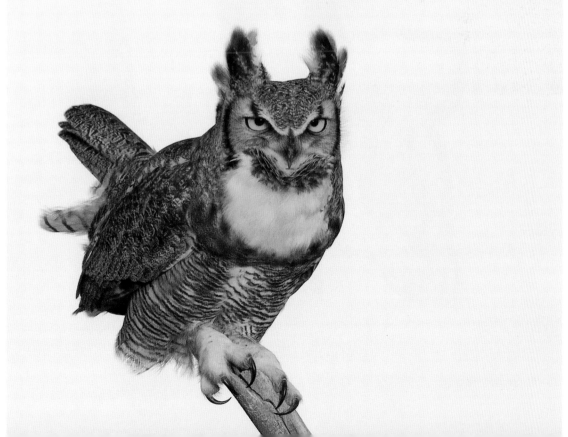

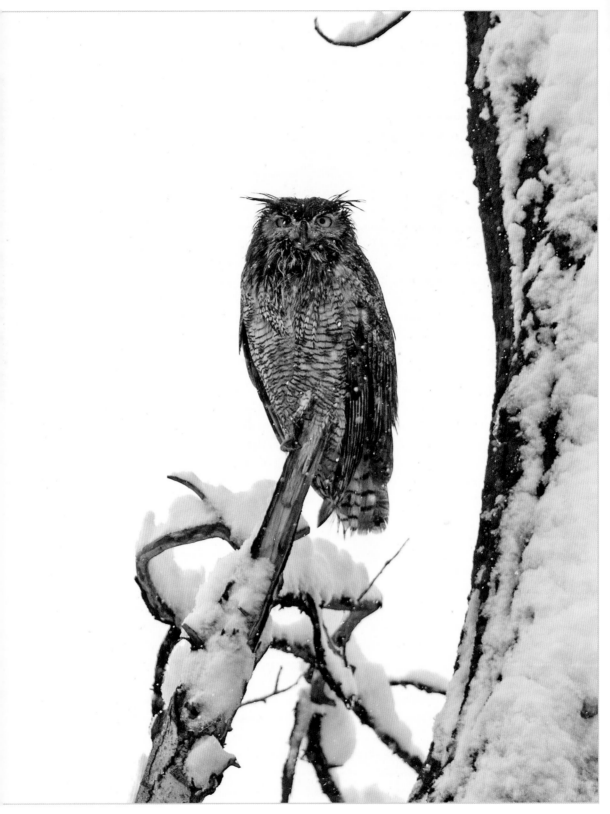

Winter Weather

above and facing page, top—Great horned owls, weathering the storm.

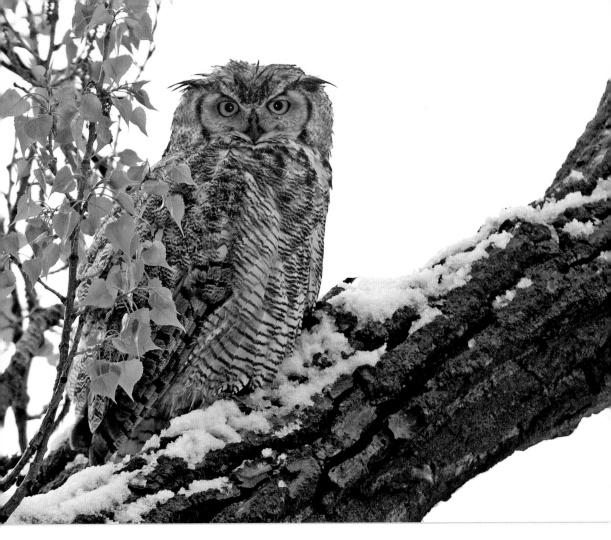

In Flight

right—This owl was sitting in a lone tree out in the open spaces of the Pawnee National Grasslands in eastern Colorado. A hawk noticed him and flushed him from his roost. The nearest tree was in-between me and him, so he flew right by me on his way to his next perch.

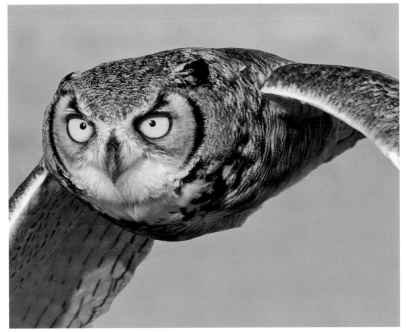

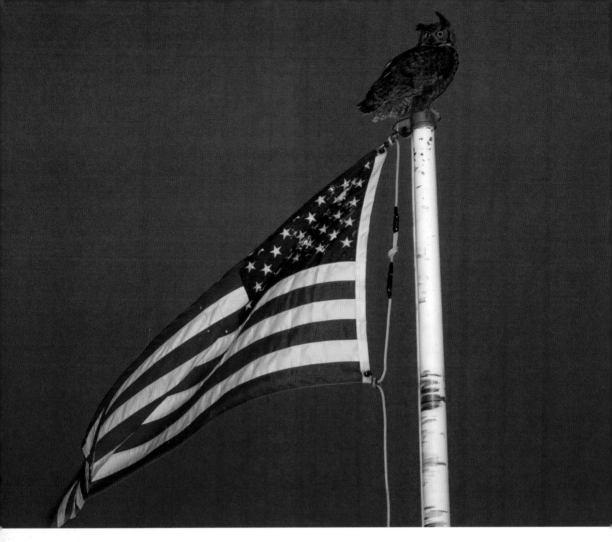

Evening

above—Late in the evening, owls will come out from their daytime perch and start calling on various perches. This one was very patriotic.

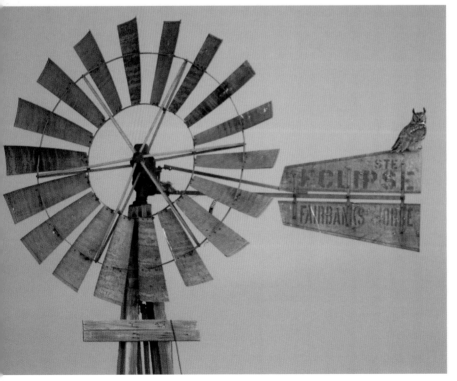

left—Here, one is calling from an old windmill in the farmlands of Eastern Colorado.

Owlets with Attitude

right—These three fledged owls look very cross.

below—In fact, young, recently fledged owls can be a formidable animal. When threatened, they open their wings to look much larger than they actually are. With their predators, such as a coyote or a skunk, this presentation will usually work. If not, a parent bird is usually close by.

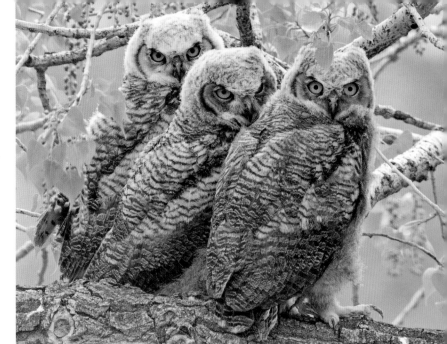

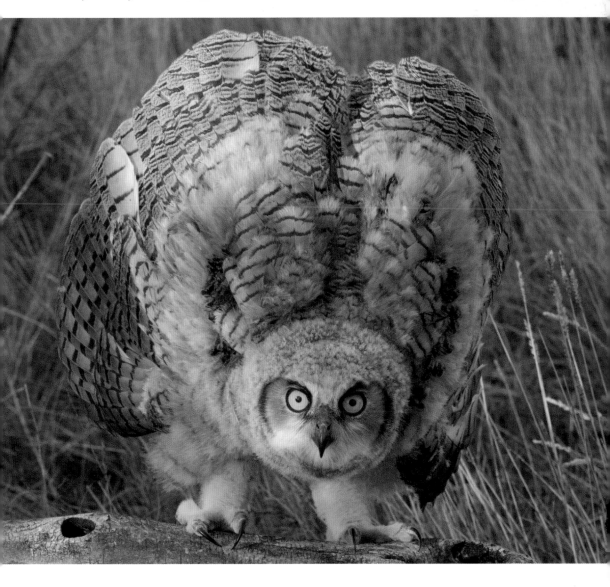

Danger!

This owl means business. I have personally been hit by a swooping owl while walking too close to a nest.

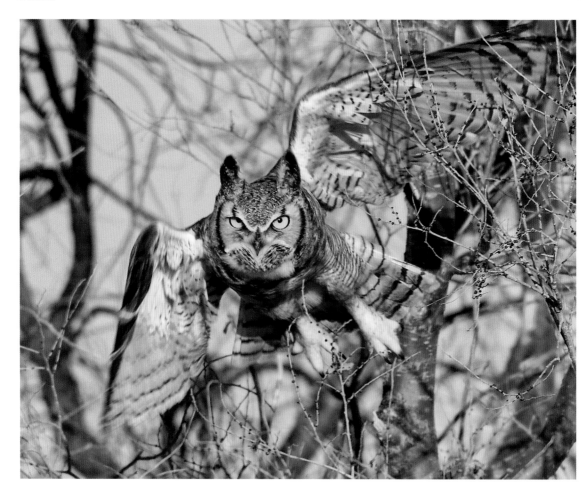

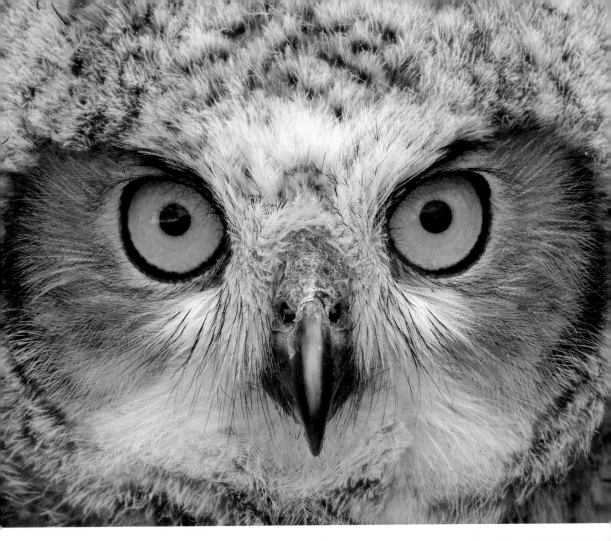

Owl Eyes

above—The eyes have it!

right—I used a little Photoshop to make this a dynamic black & white image with the emphasis on the eyes.

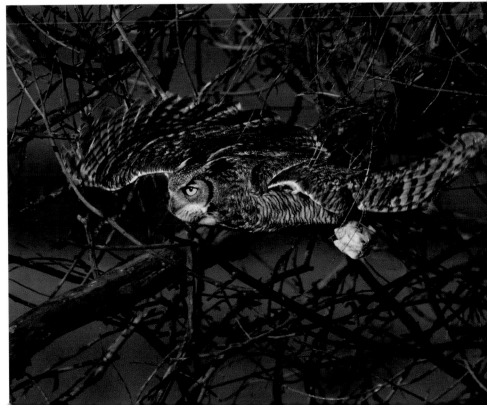

Talons

The great horned owls' formidable talons are their main weapon. Exerting a pressure of over 500 pounds per square inch, they usually have no trouble subduing their prey. This could include rabbits, skunks, snakes, and other large animals.

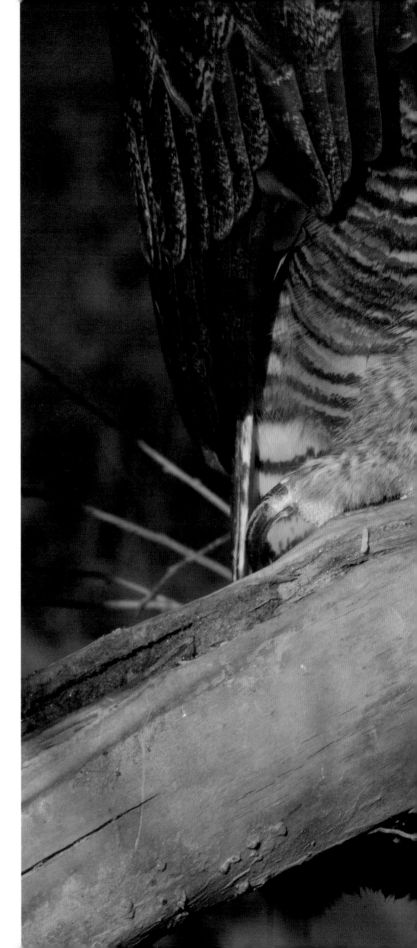

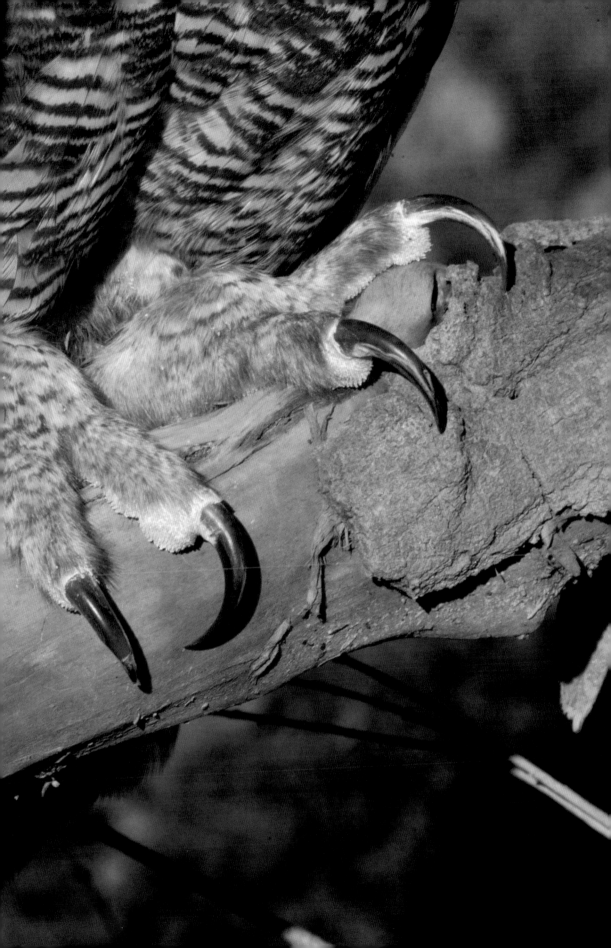

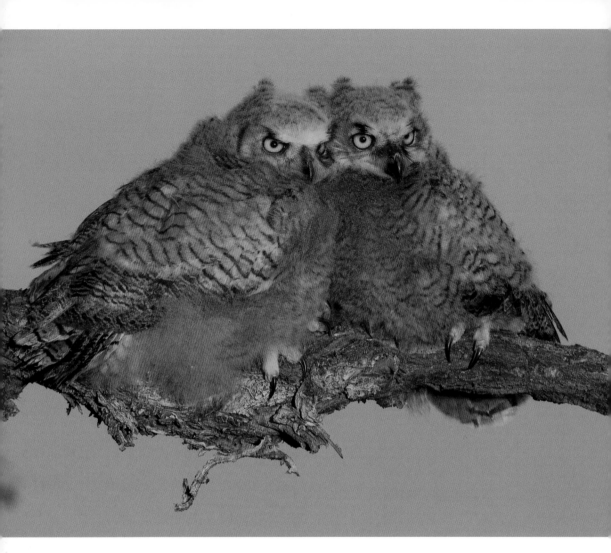

Fledglings

above—Two newly fledged owls sitting next to each other in the late evening light.

facing page—A recently fledged owlet climbing up a nearby cottonwood tree. Great horned owls fledge at about four to six weeks but cannot fly until they are about eight weeks old. So, for a couple of weeks, they just stay quiet in nearby trees close to the nest. Many times they fall out of the tree and onto the ground, but they quickly find the nearest tree and climb using their talons to grip and their wings for balance.

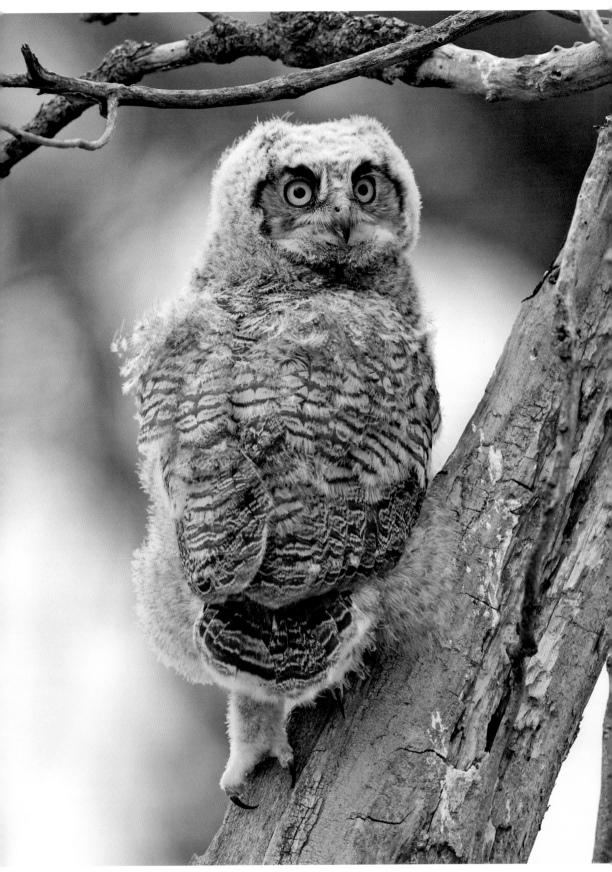

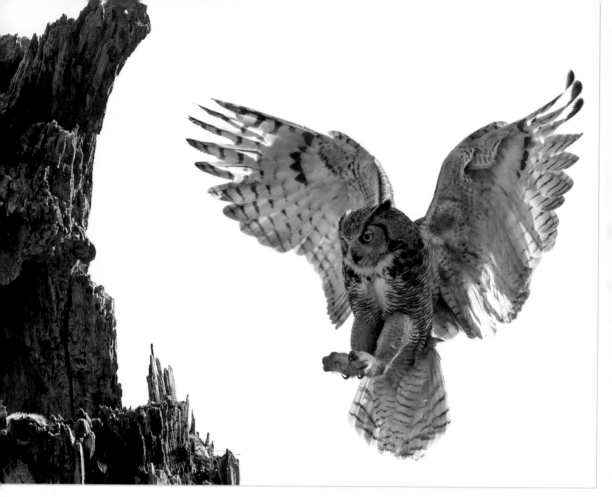

Timing

above—A great horned owl parent landing on a snag. You can see one of the young owls if you look closely. Getting the timing right for the landing is the key to capturing a good photograph. This pair of owls were very cooperative.

Old Barns

below left—Great horned owls, along with barn owls, very often use old barns and abandoned farm houses as a place to breed. Usually, the nest is placed on the top floor in a corner somewhere. They don't make a nest, they just use what is there. Sometimes they nest on top of some old hay or sometimes just on the floor itself.

facing page—Spring storms don't stop great horned owls from nesting. This one happened to be nesting inside an old barn.

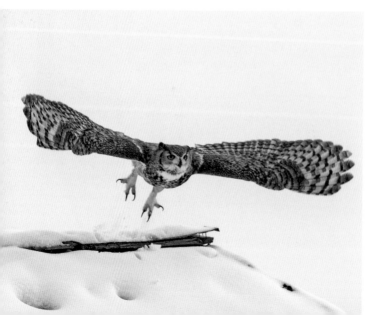

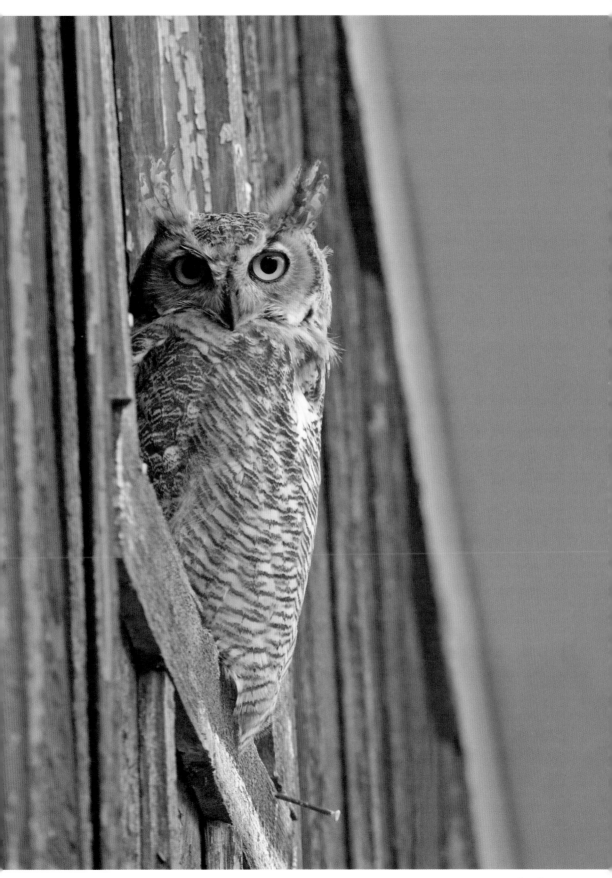

2. Barn Owl

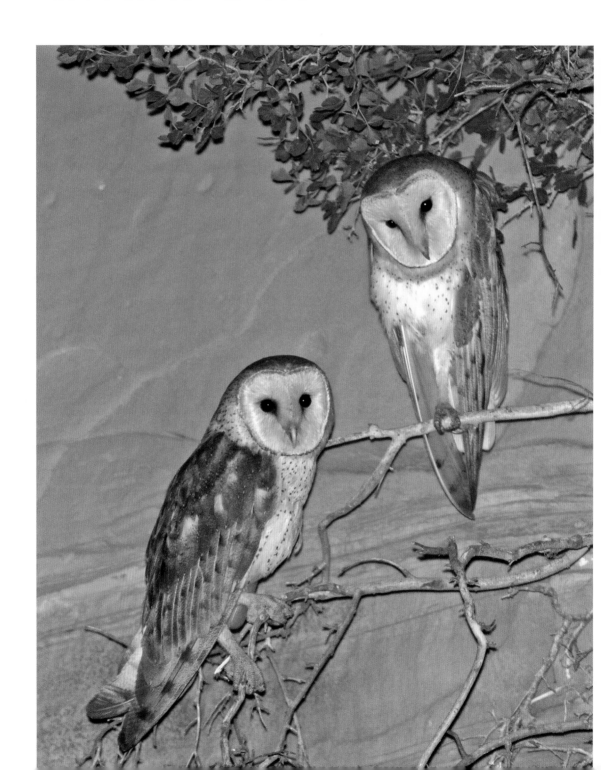

Barn owls are fairly common in most of North America. They have mostly nocturnal habits but will fly during the day if prey populations are plentiful or hunting conditions are favorable.

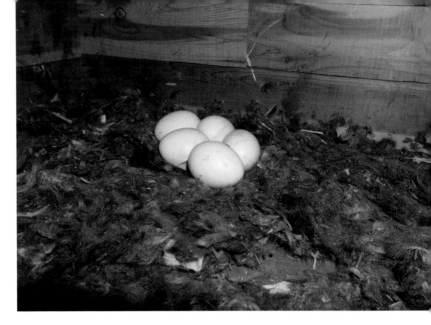

Nesting

top right—Barn owls commonly nest in old buildings, barns, farmhouses, and snags in dead trees. This one was in a kitchen cabinet of an abandoned farm house. Four to eight eggs are common.

below—This nest was located in a ventilation shaft in another old farm house. The photo shows the age difference between the oldest owlet and the youngest—as well as some of the food the owls eat.

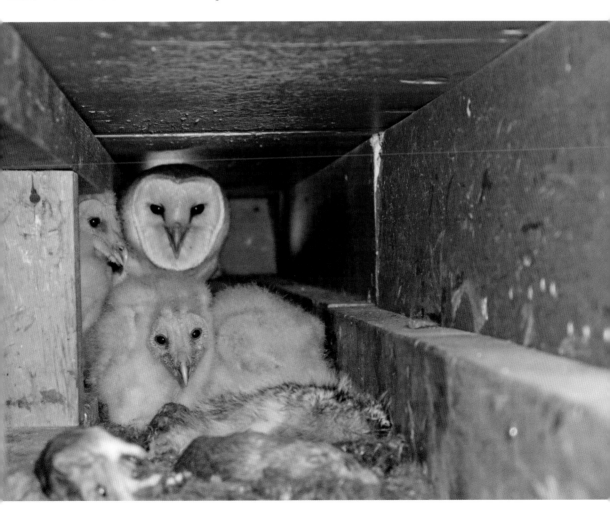

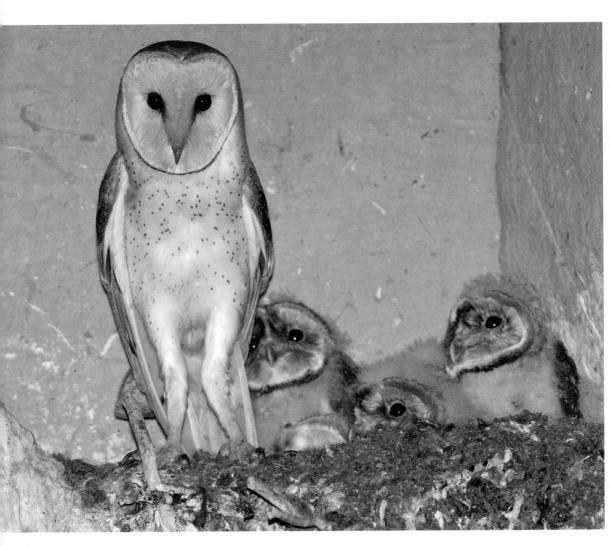

Parenting

above—A parent owl watching over her brood. There are actually seven owlets in the nest, some hiding under the other ones.

left—Here are three of the seven owlets posing very nicely.

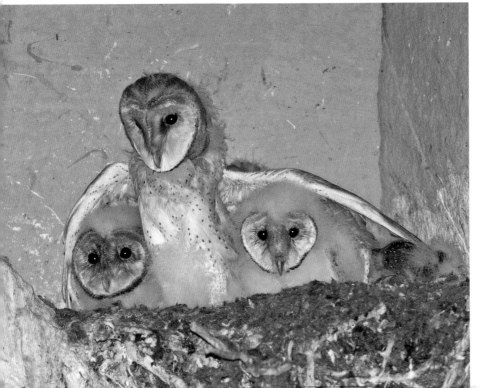

right—An adult owl leaving the nest after dropping off some food.

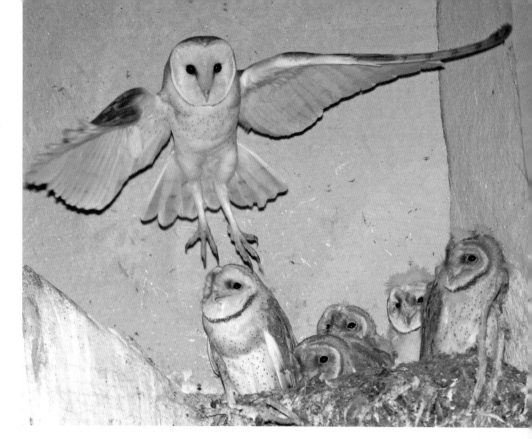

below—Five of the seven owlets staring at a sibling that is almost ready to fledge from the nest.

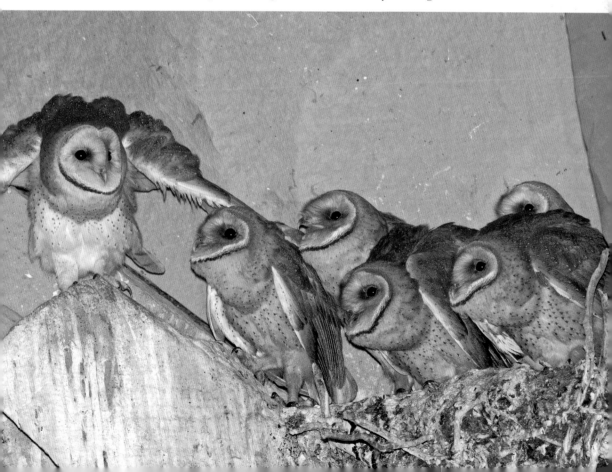

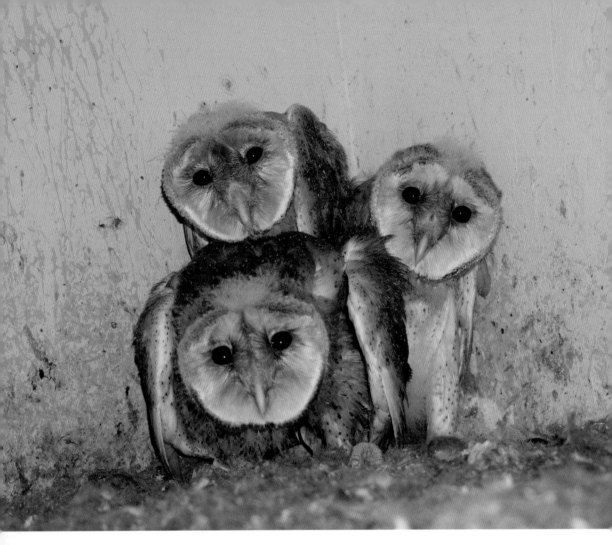

Year After Year

above—This nest is the shelf of a closet in an old farmhouse. It is my hope that many of these old houses remain intact. They make a beautiful home for the owls (not so much for humans anymore).

left—This is the same nesting spot as the previous one, but a year later with a different brood.

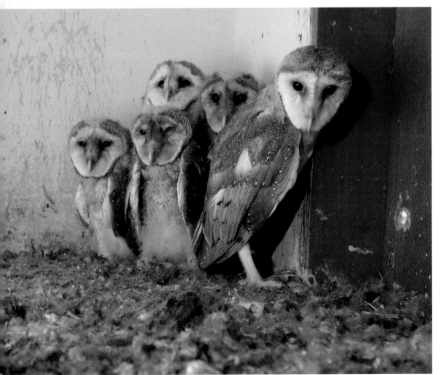

Nest in a Cottonwood

right—This nest is in a dead cottonwood tree, with four of the five owlets staring out.

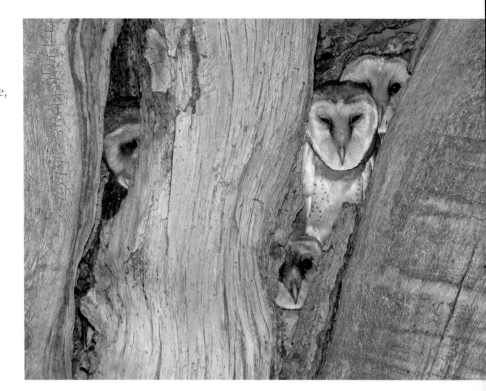

below—Here comes the parent bird with a tasty morsel for the brood.

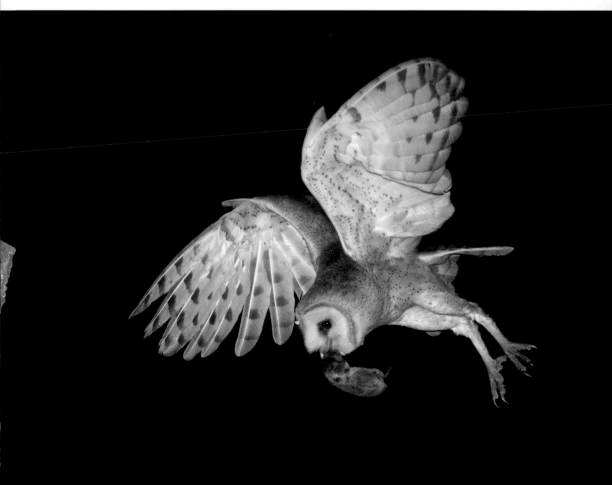

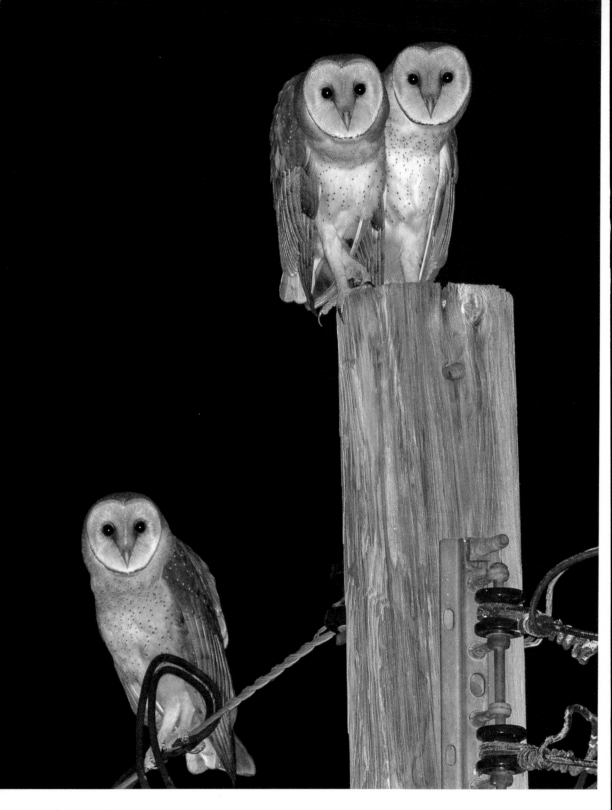

Close to Home

Once the owls fledge, they usually hang out fairly close to the nest hole
while waiting for the parent bird to bring them food.

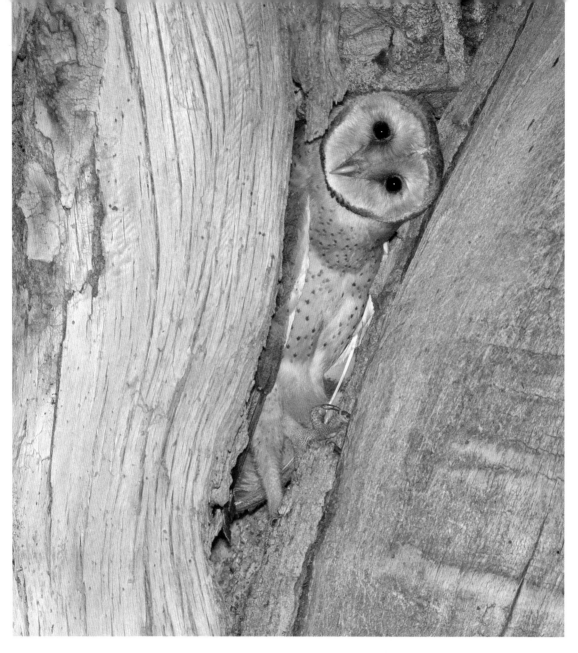

Twists and Turns

One of the things I love about owls is the way they can turn their heads in all sorts of different angles. Some say it is because of the way they focus their eyes, but I say they are just curious.

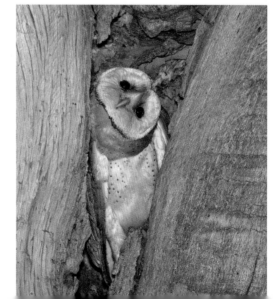

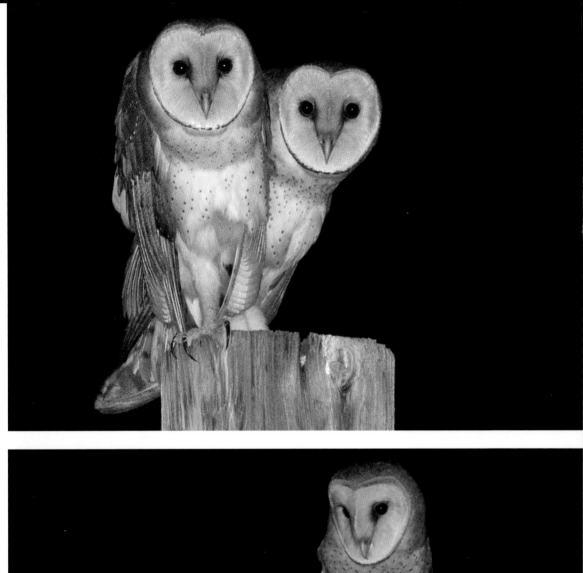

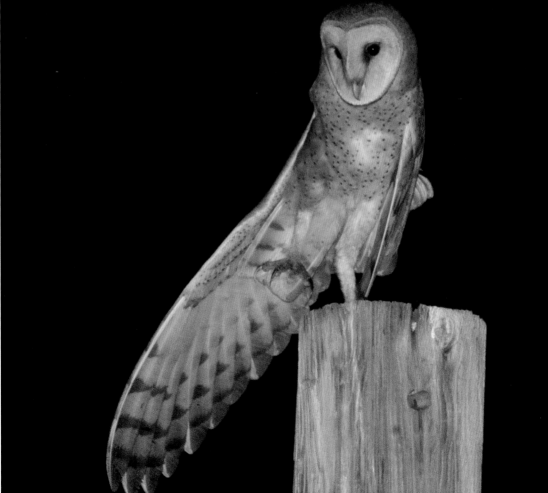

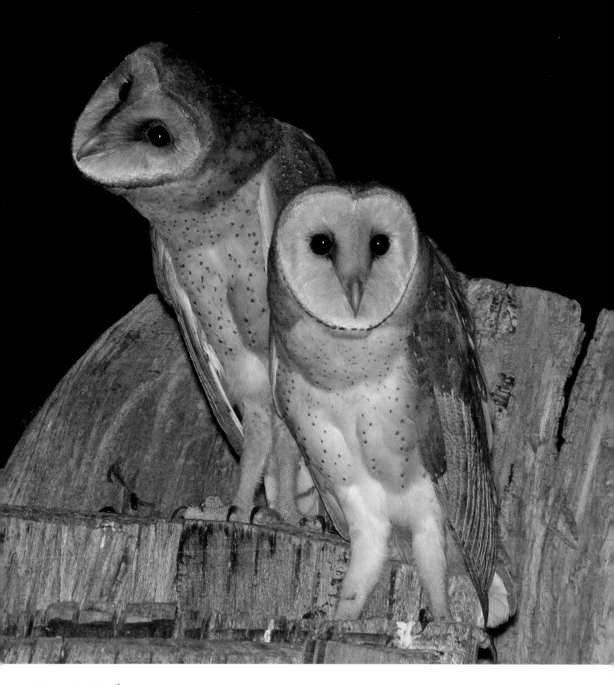

A Favorite Perch

facing page—This pole was the owlets favorite perch while waiting for the parents.

Coloration

above—Two young owls hanging out on top of the dead snag that their nest is in. Note the color difference in the owls. The front owl is lighter and is most likely a male.

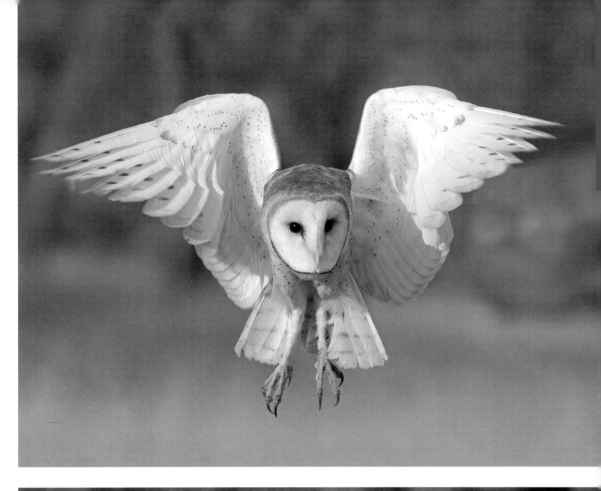

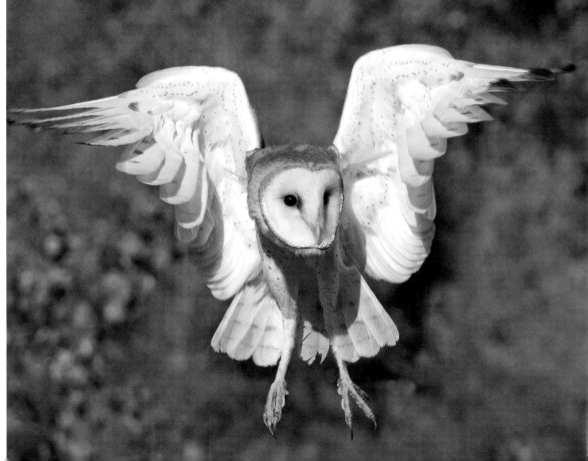

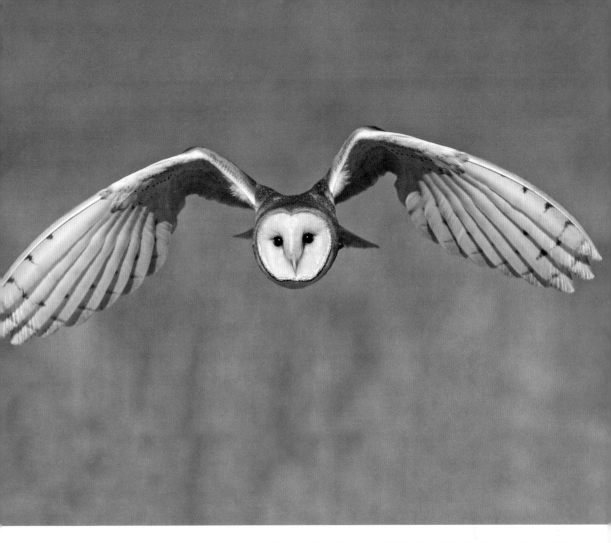

Landing

A few different flight shots of a young barn owl coming in for a landing.

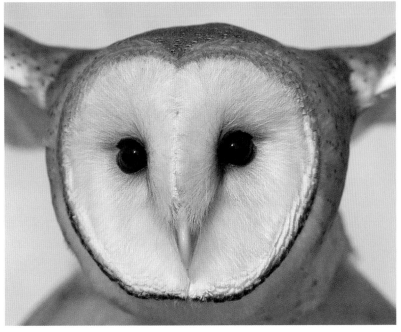

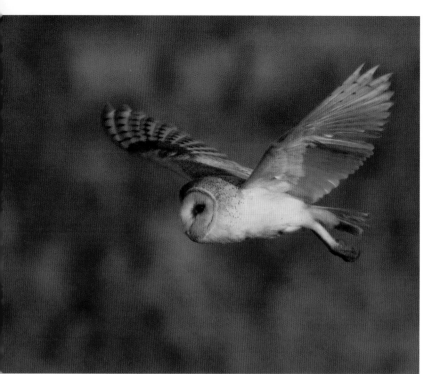

Day Hunting
A barn owl hunting during the day. When prey populations are low, barn owls can and will hunt during the day.

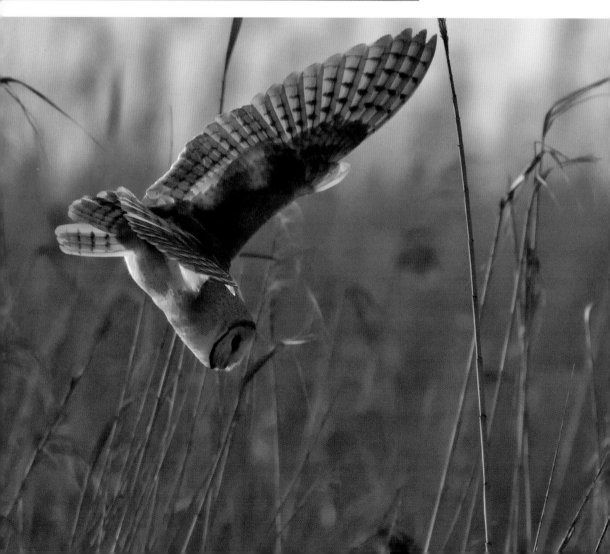

Beautiful Babies?

right—Owlets might not initially be the cutest babies in the animal world!

below—In a couple weeks, however, they really do develop very pretty faces.

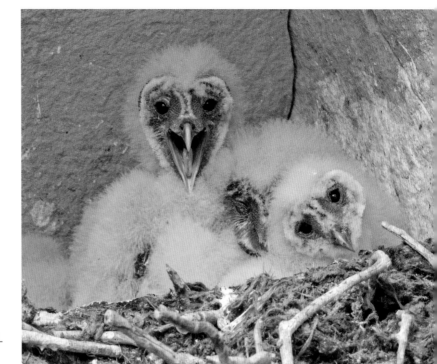

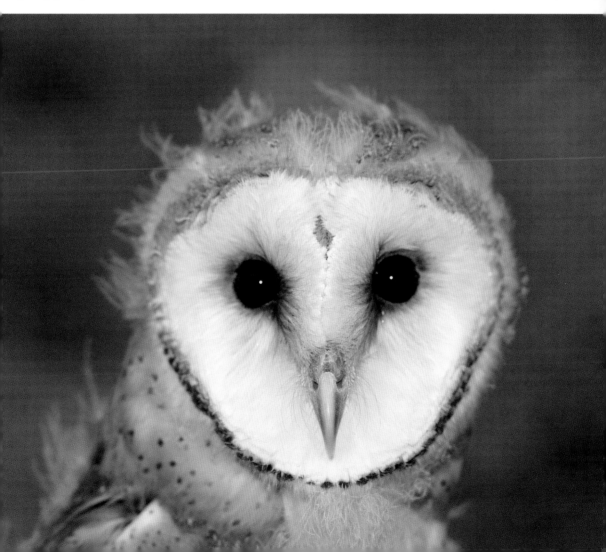

3. Snowy Owl

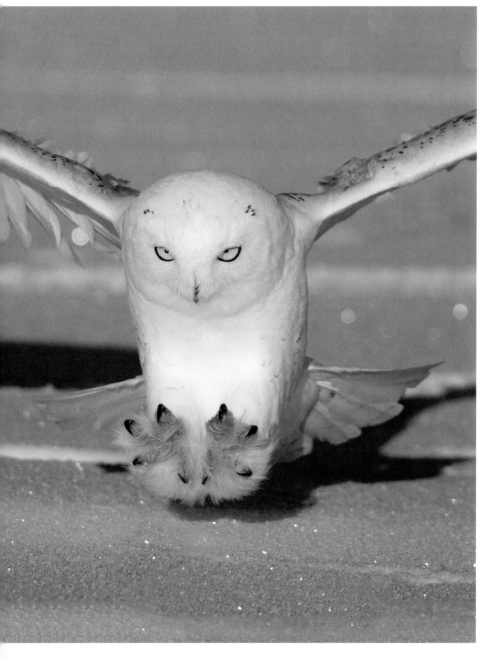

Snowy owls spend their summers in the high Arctic, raising up to ten chicks at a time when the prey population is good. They venture south during the winter to the northern states—and sometimes even as far south as Texas. This beautiful male was found near Colorado Springs during a particularly cold winter.

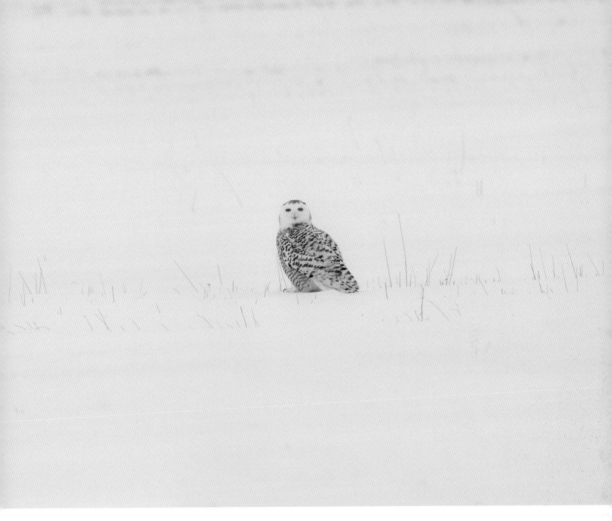

Hunting

above—Here, a lone immature bird is found in a snow-covered field. Snowy owls will hunt during both the day and night, so they are fairly conspicuous.

right—A close up view of a snowy owl out in a field of wheat stubble. Owls hunting in fields like this are most likely looking for voles to feed on.

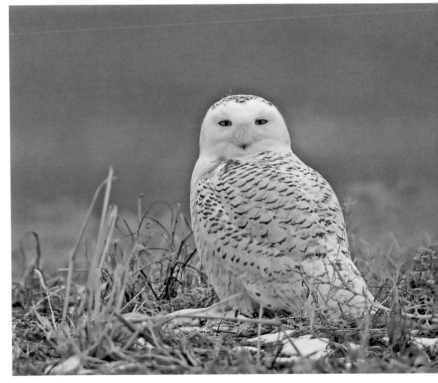

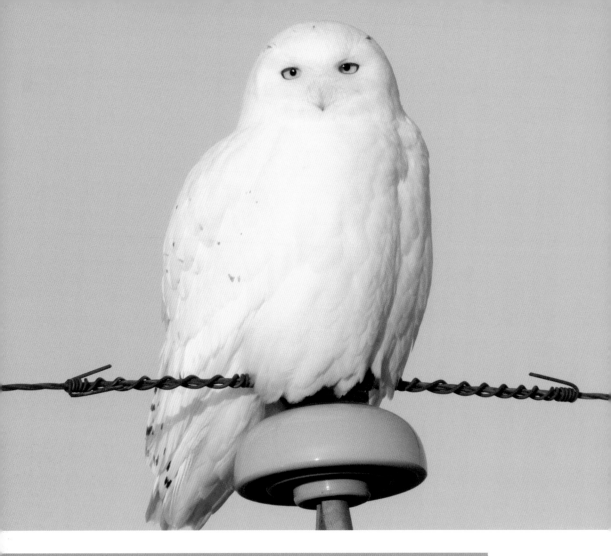

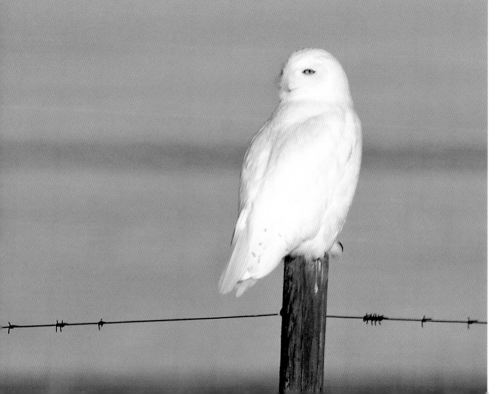

Favorite Spots

In areas where there are lots of snowy owls in the winter, it is fairly common to see snowy owls on top of telephone poles and fence posts, surveying the area for prey. The adult males are almost pure white.

Female Snowy Owls

right—There doesn't always have to be snow where the owls hang out. This one was in South Dakota. Most likely, it's an adult female, which are fairly hard to distinguish from immature birds.

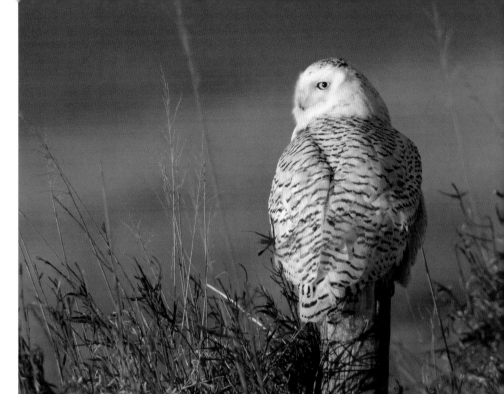

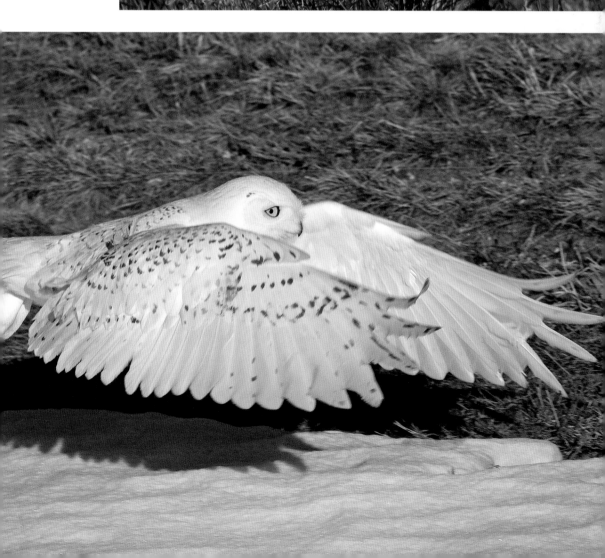

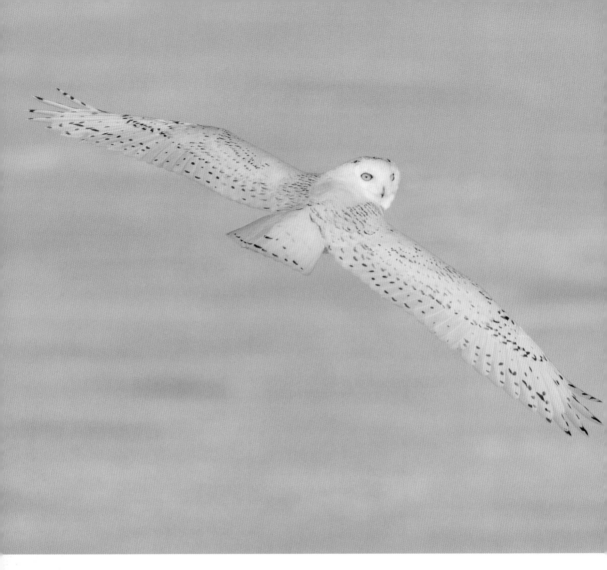

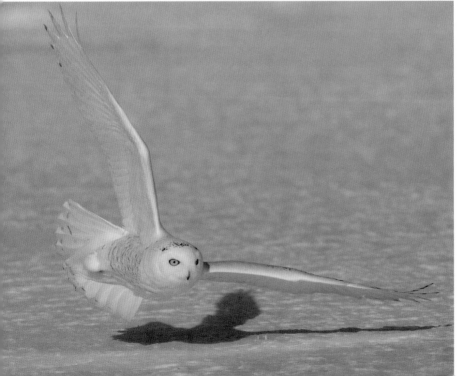

In Flight

above—The owl is looking over her shoulder to investigate the clicking sound of the camera.

left—Flying low against the snow to blend in with its surroundings.

facing page—A beautiful immature bird against a blue sky.

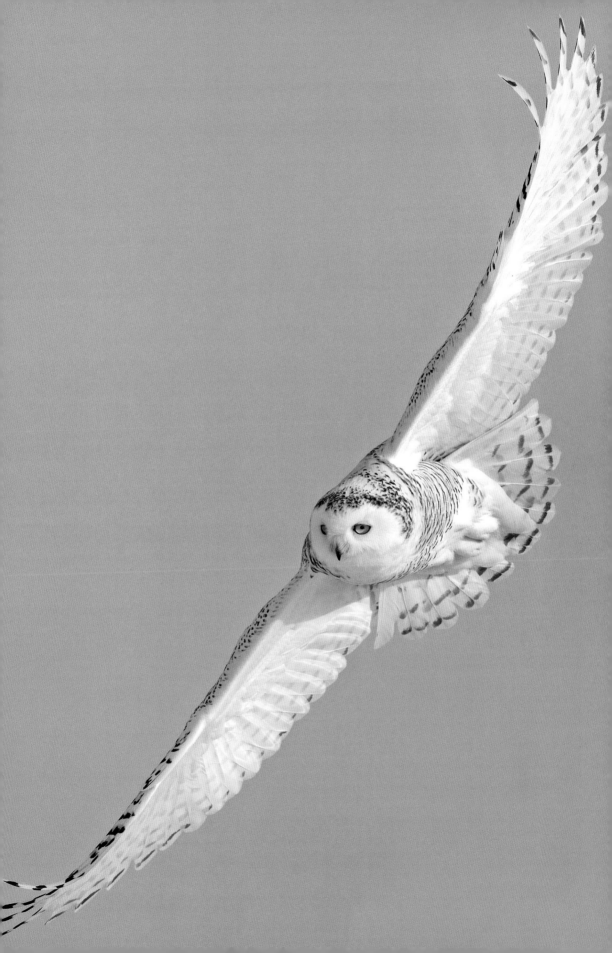

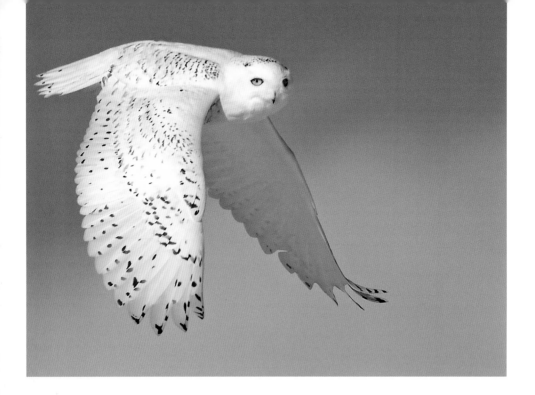

Counterbalance

below—Snowy owls will sometimes lower one of their legs when coming in to capture prey. It is thought that this may be used as a counterbalance as they descend to grab their meal.

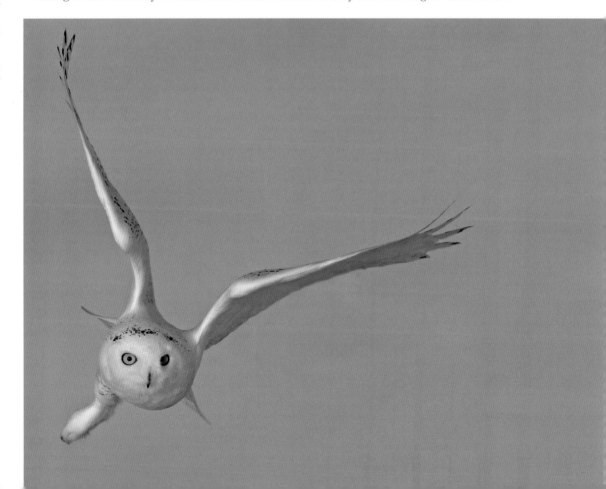

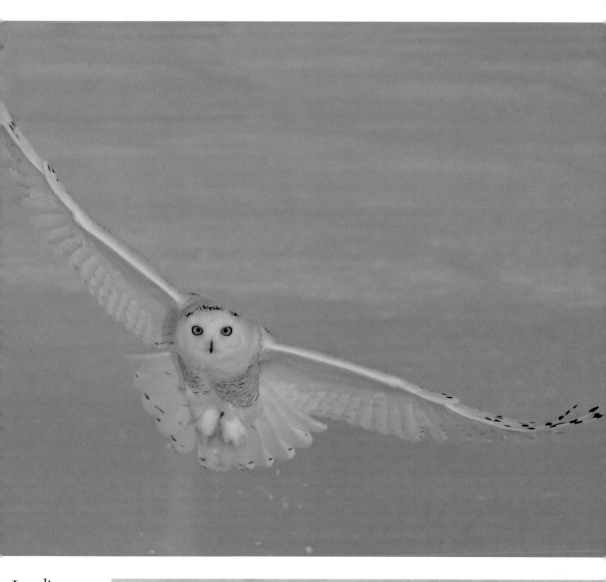

Landing
above—Coming in for a late evening snack.

Camouflage
right—Can you spot the owl?

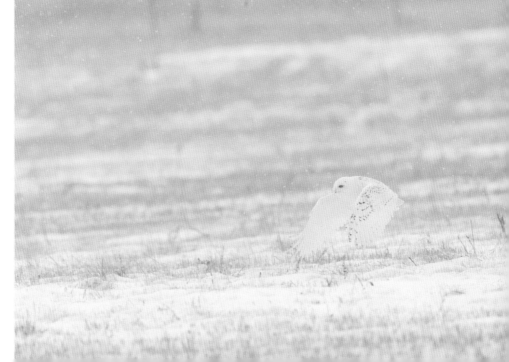

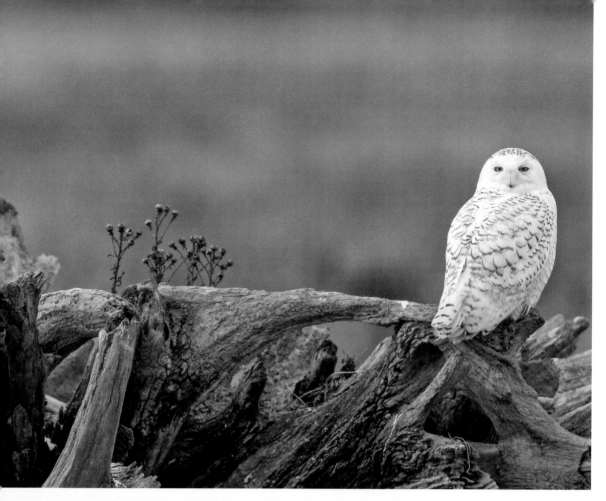

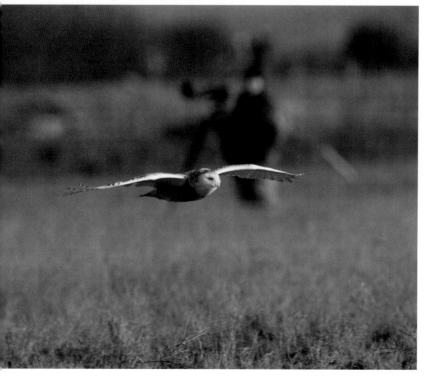

British Columbia

The next sequence of photos was taken in southern British Columbia during an owl irruption. There were a total of twenty-seven owls in one area along the coast. This is very unusual and was most likely caused by a good summer for breeding followed by a bad winter, causing all the birds to migrate to this area.

left—Here, a photographer watches as an owl flies by.

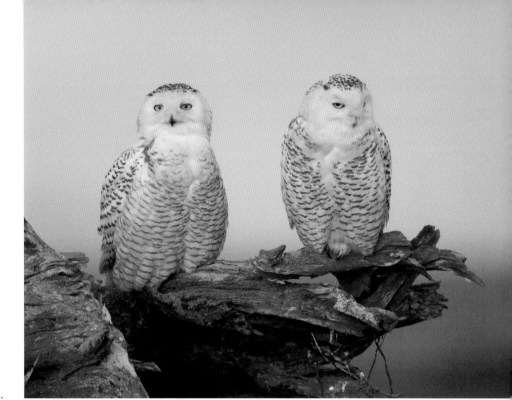

below and right—
A pair of young
snowy owls on
some driftwood.

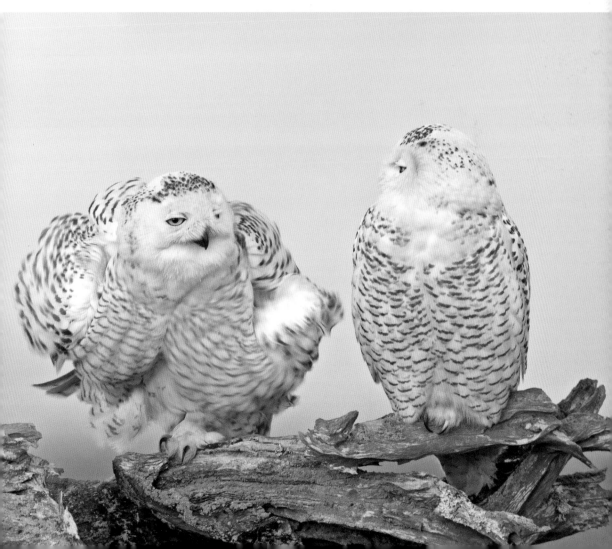

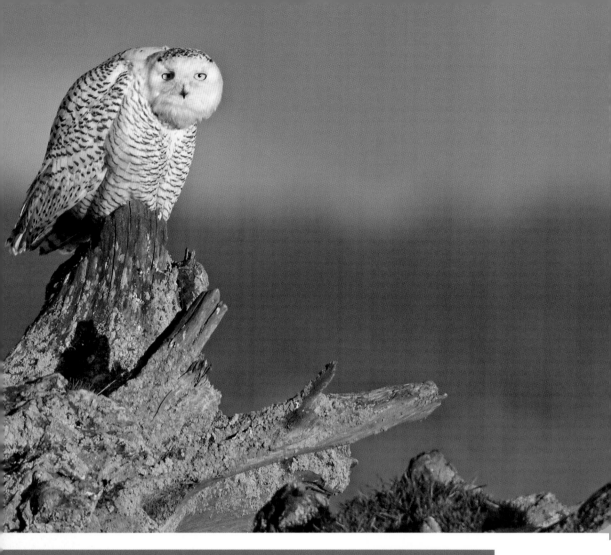

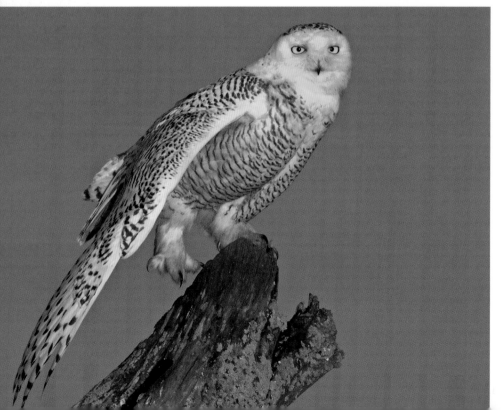

left—A young
owl doing a
wing stretch,
sometimes
called a
"warble."

right—An owl sits on some driftwood with the mountains in the background.

below—A young owl coming in for a landing.

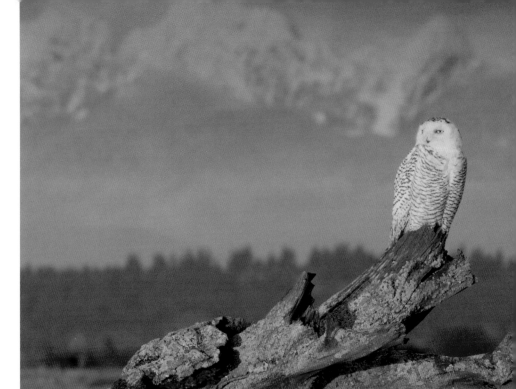

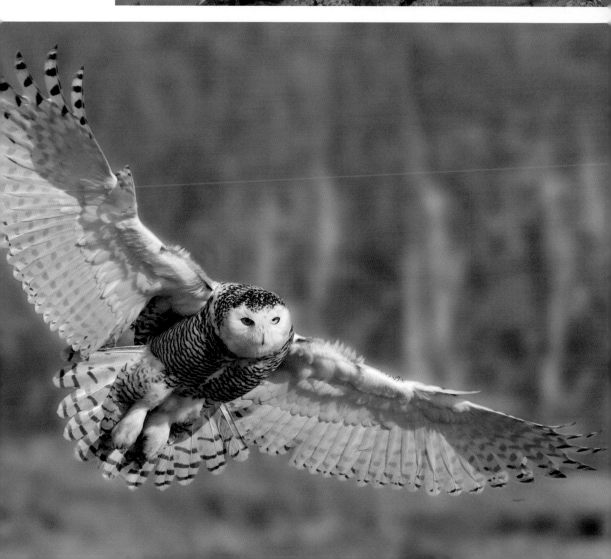

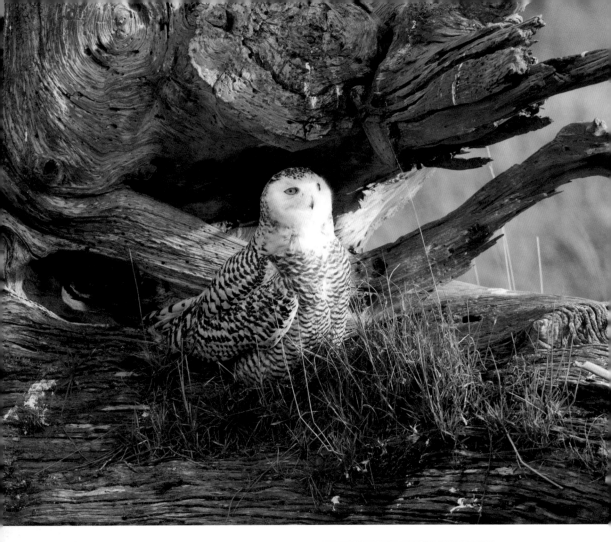

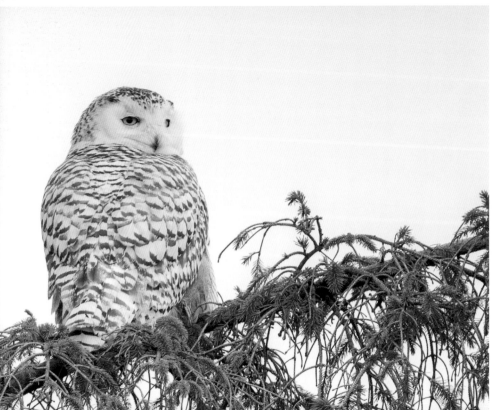

above—A young owl lounging under a tree stump in the late morning.

4. Great Grey Owl

Great grey owls are large and found mainly in Canada and the northern United States. With a wingspan of over four feet, they can look very ominous. However, they have very small feet that are used for catching mice and voles. They rarely take prey any larger than this.

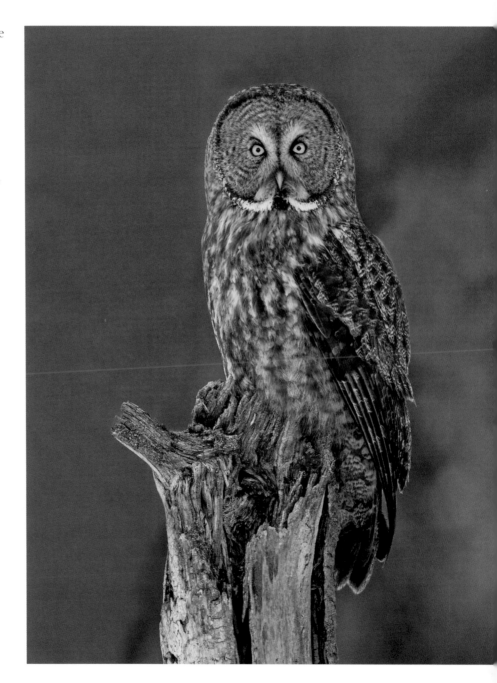

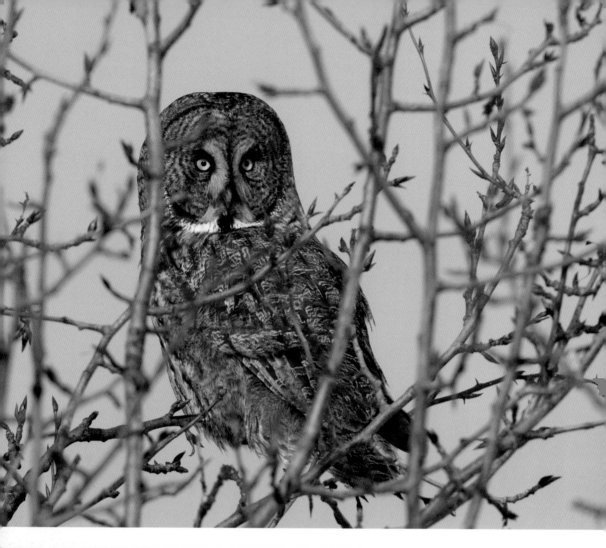

Vole Hunting

The next sequence of photos shows a great grey owl pursuing a vole in the deep snow of northern Canada.

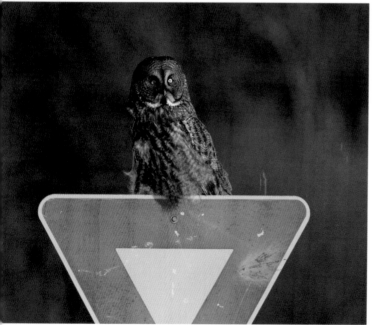

above—First, from his perch in a tree, he spots or hears his prey under the snow.

left—Then, he flies down to a lower perch to get his bearings. In this case, he perched on a yield sign.

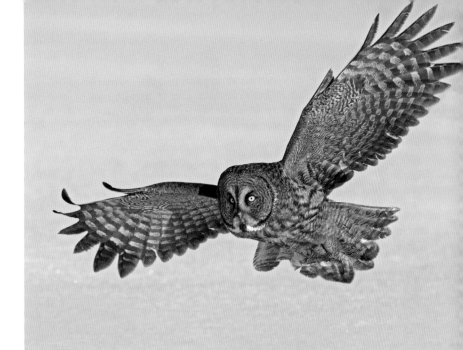

right—He starts his attack.

below—Here he comes!

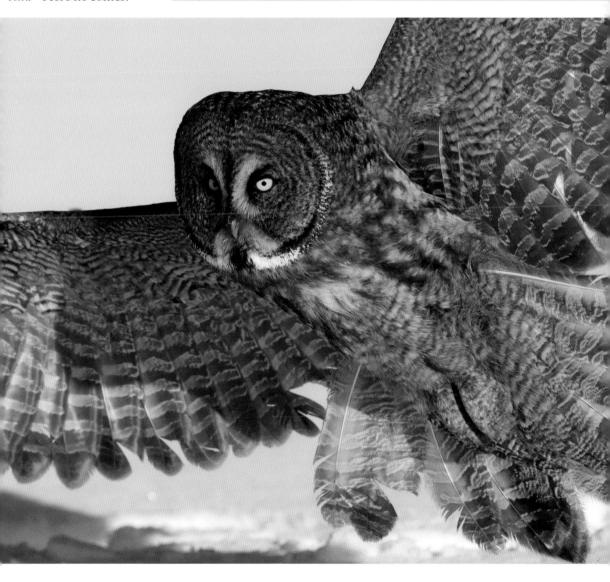

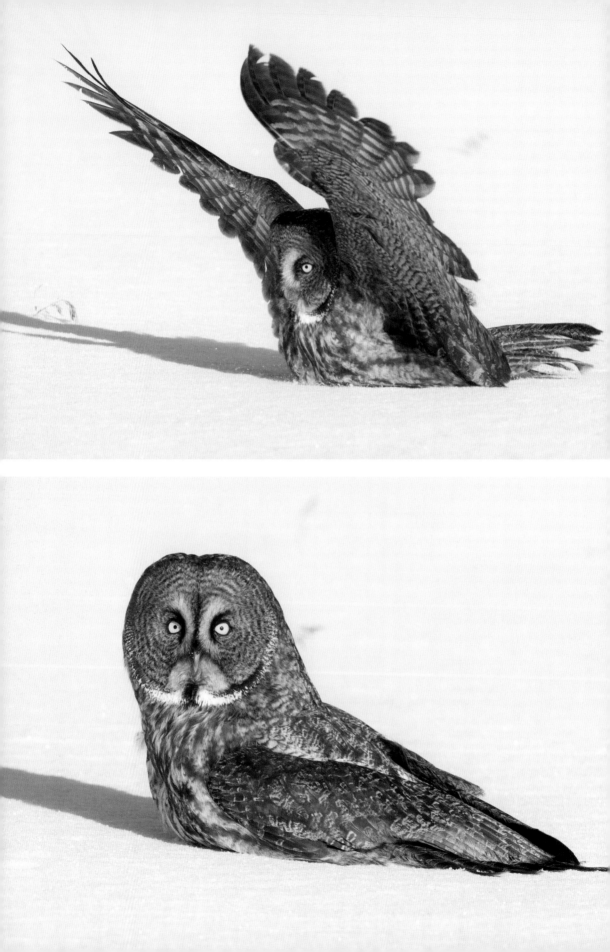

facing page, top—Success! Although it doesn't look like it, he has caught a vole under the snow.

facing page, bottom—He takes a look back at the camera before settling down.

below—The owl is sitting on his prey, relaxing after the flight. I like to call this photo *Cousin It's Cousin* or *A Living Feather Duster*.

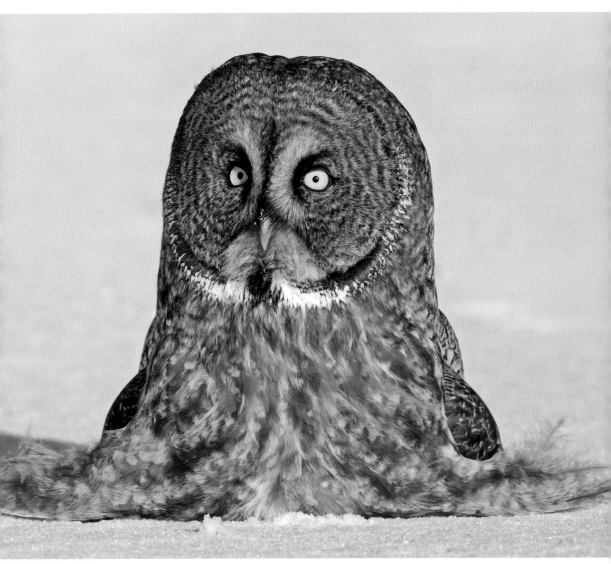

Nesting Pairs

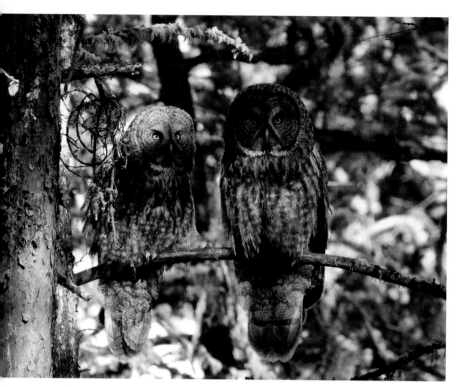

left—A mated pair of great grey owls. *Photograph by Dan Hartman.*

below—A great grey owl peering out from a nest in an old stump of a coniferous tree. These owls nest very early and it is common for snow to fall while the birds are incubating eggs. *Photograph by Dan Hartman.*

facing page—A parent owl with two chicks. *Photograph by Dan Hartman.*

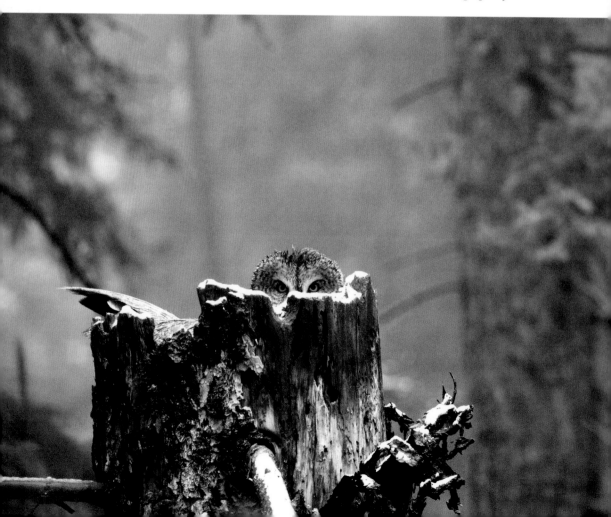

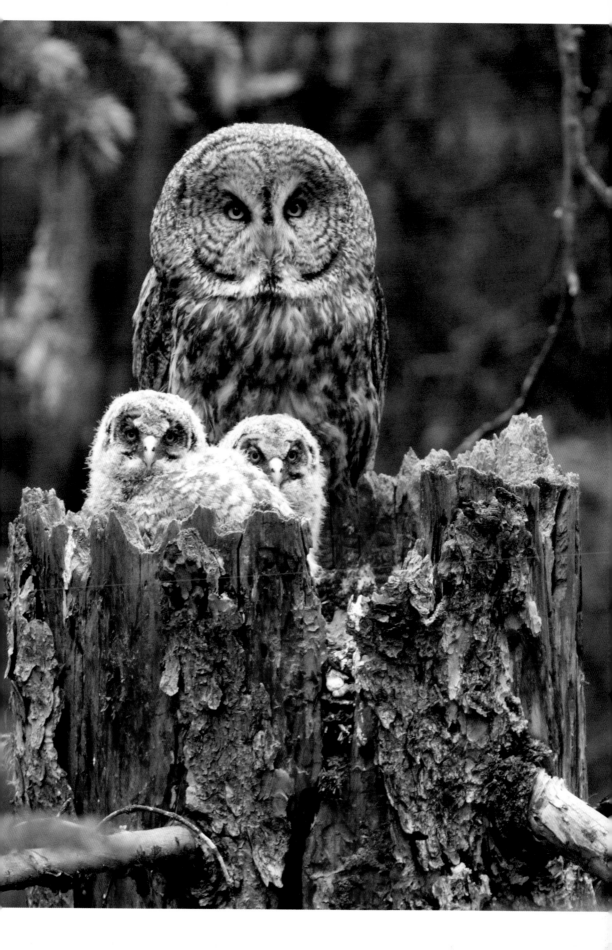

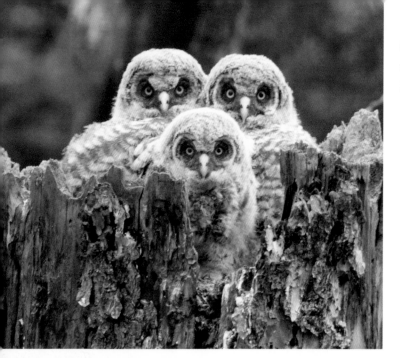

top left and facing page—Three's a crowd! *Photographs by Dan Hartman.*

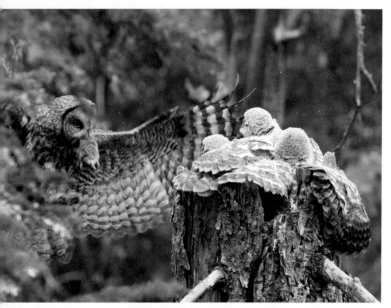

left, center and bottom—Parent birds bringing voles back to the nest. *Photographs by Dan Hartman.*

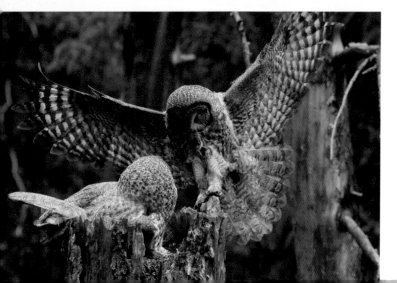

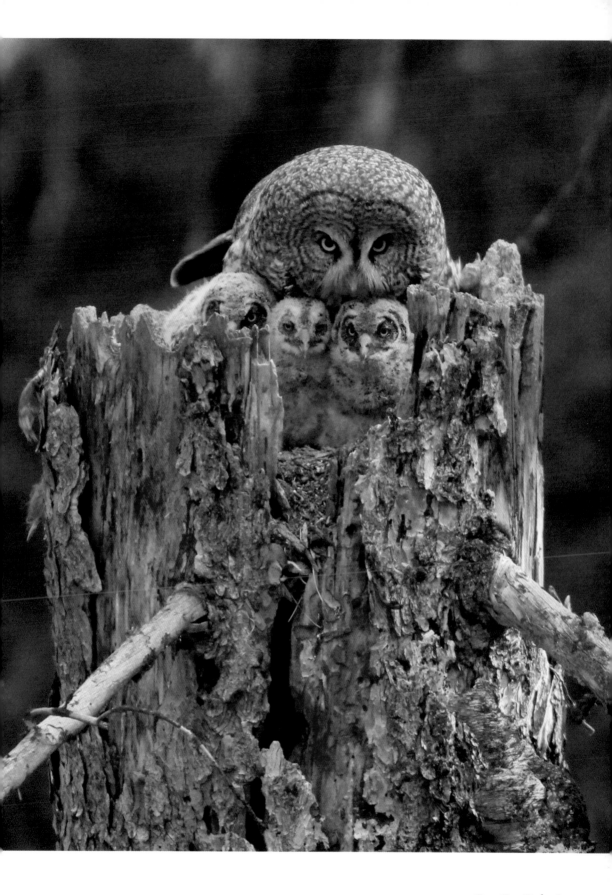

5. Short-Eared Owl

The short-eared owl is a medium-sized bird that can be seen in the early morning and evening, coursing over the grasslands in search of small rodents.

Resting and Roosting

below—Short-eared owls often use fence posts as their resting place in between flights.

facing page, top—On grasslands, the owls will roost in rows of thick junipers or other evergreens during the day.

Late Afternoon

facing page, bottom—Because they fly late in the afternoon, sometimes the light cast on them is wonderful. They will also turn and look at the sound that is being made by the camera which is great for eye contact.

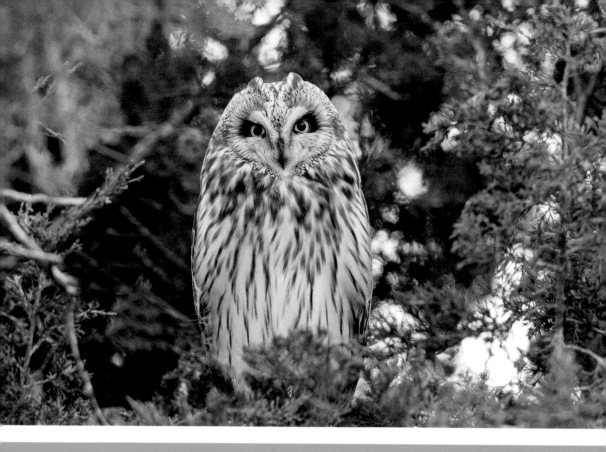

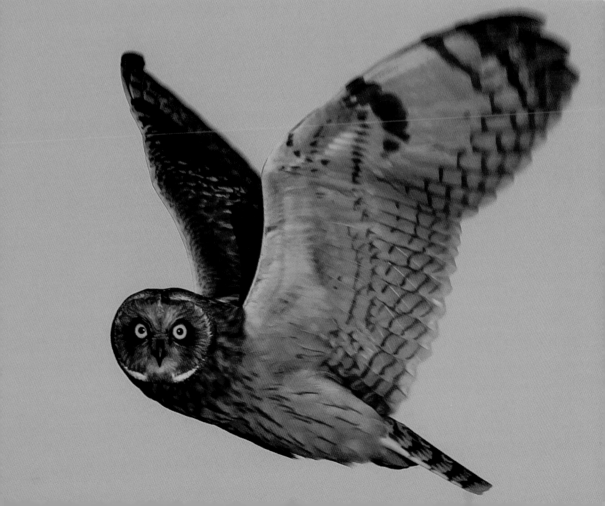

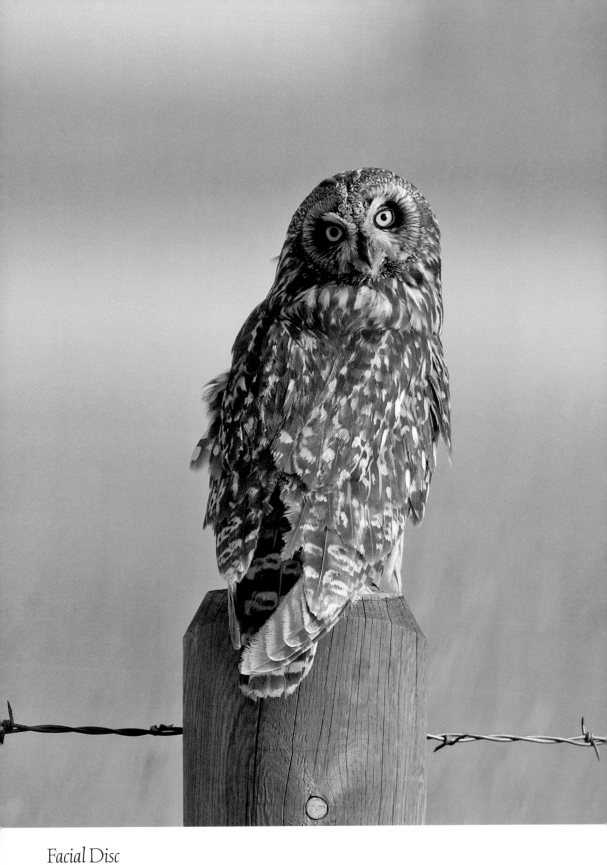

Facial Disc

above—A short-eared owl stares at me while I photograph him from my car. Note the facial disc on the bird. This is used while hunting to locate prey using sound.

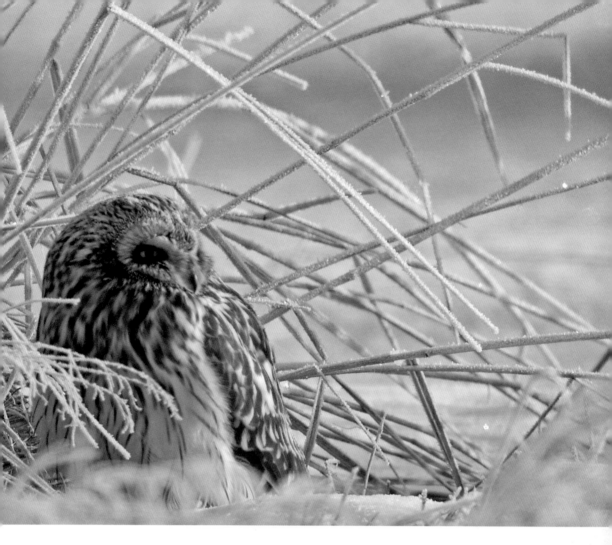

Camouflage

above—When there are no trees around, short-eared owls will settle themselves in the grass using their cryptic coloration to blend in with the background.

Chasing Each Other

right—When there are two or more owls in the same area, they will sometimes chase each other. This presents photographers with a rare opportunity.

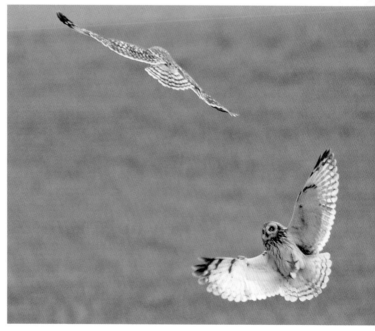

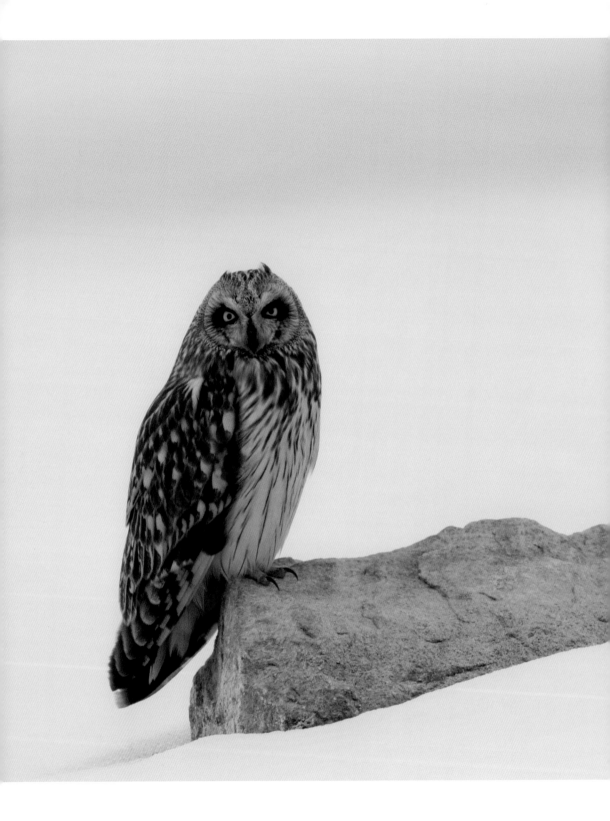

"Ear" Tufts

left—Here we see a short-eared owl on a cold morning on the plains. Note the very small tufts of feathers on top of his head that give this bird its name. These tufts are not really ears, however; they are just feathers that help channel the sounds into the ears.

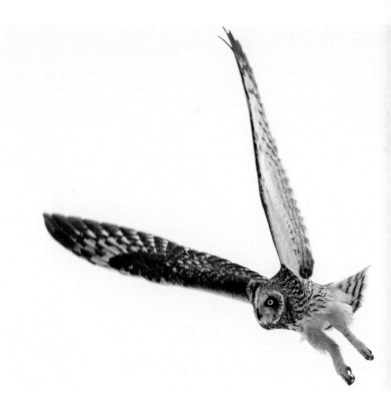

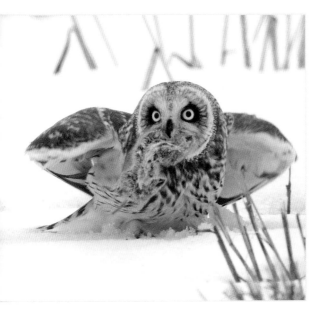

Hunting

above—Here a short-eared owl has found a large vole on a snow-covered field.

right—A short-eared owl hunts among the phragmites in central Utah.

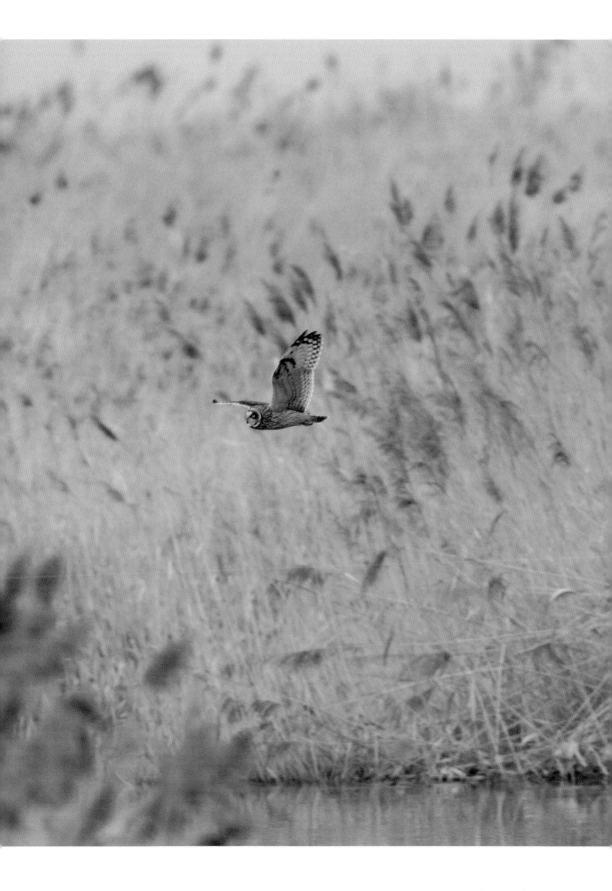

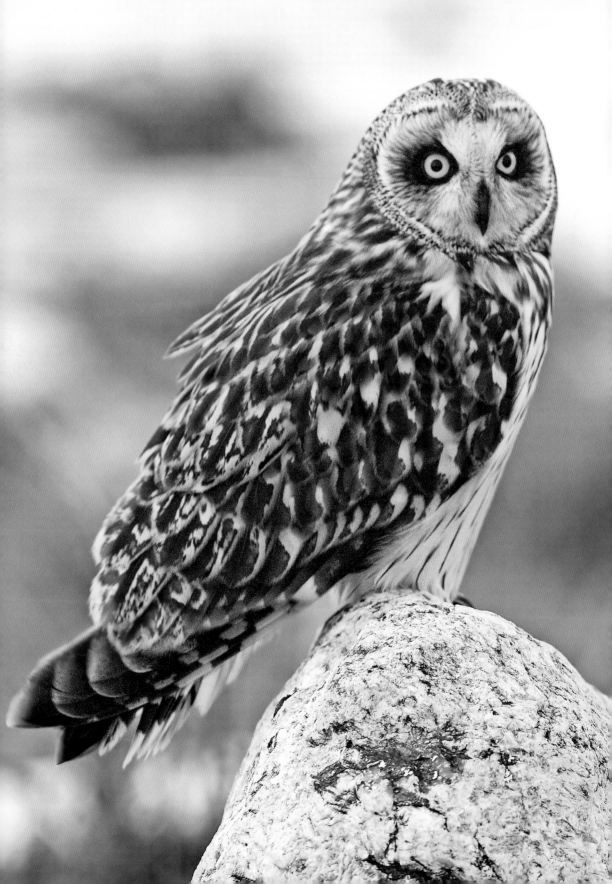

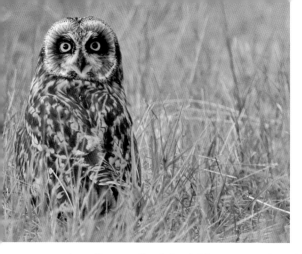 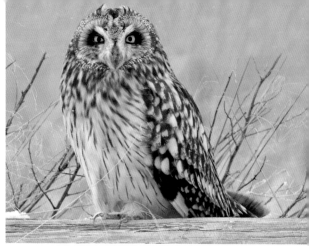

above, left—A really nice "look back" from an owl in the grass.

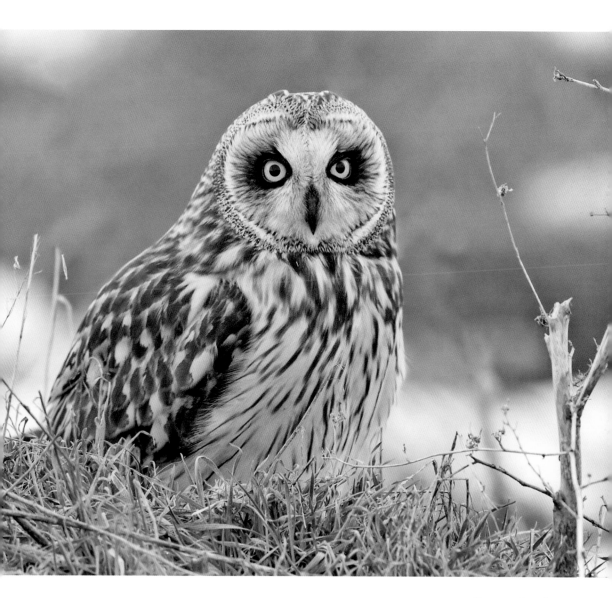

6. Long-Eared Owl

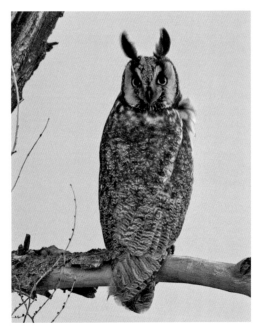

Long-eared owls are close relatives of short-eared owls but have long ear tufts. They are more nocturnal than their counterparts and are usually found in very thick cover. I really got lucky with this guy (*above*).

Camouflage

right—Long-eared owls use the thick cover to hide during the day. They will also nest there using the old nests of magpies, crows, and hawks.

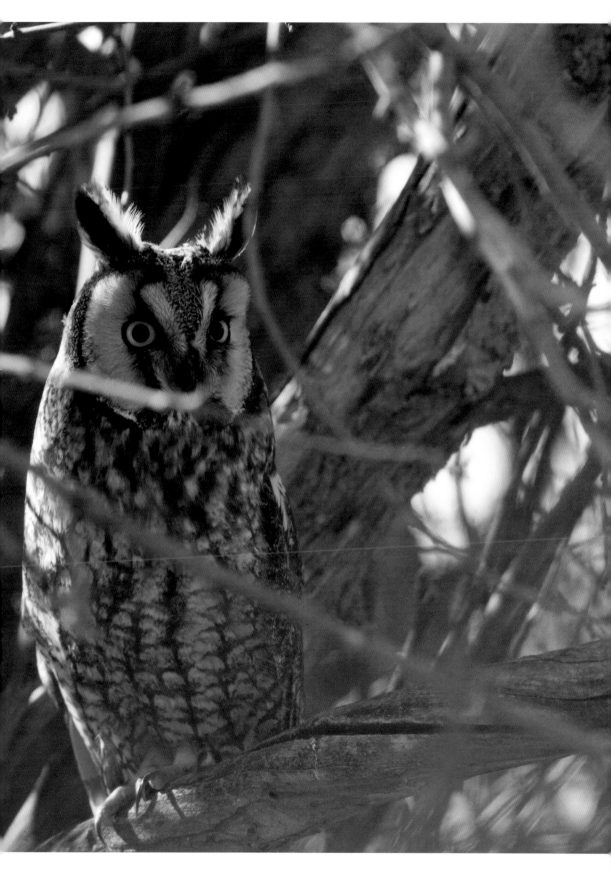

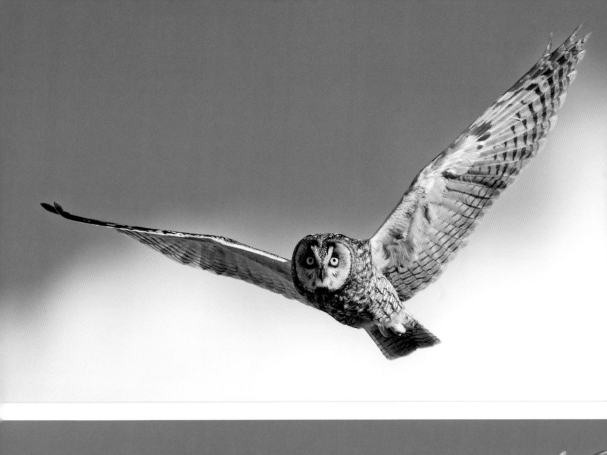
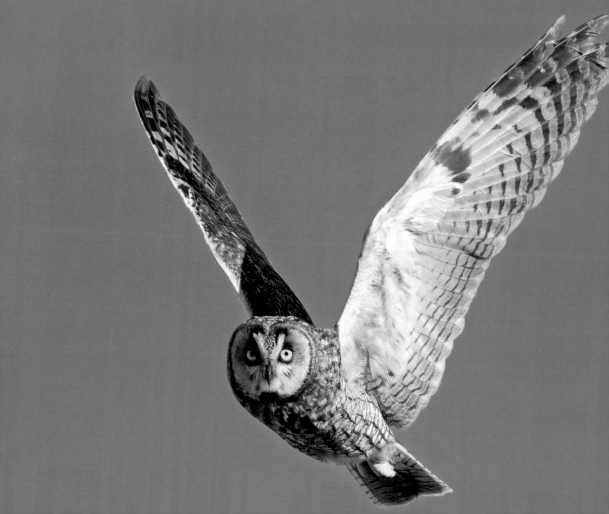

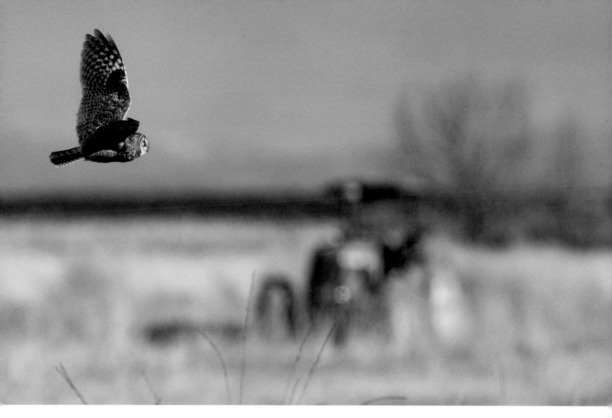

Habitat and Nesting

above—A photo showing a typical habitat where the long-eared owls can be found.

below—Like most owls, long-eared owls do not make their own nests. This one is in an old magpie nest.

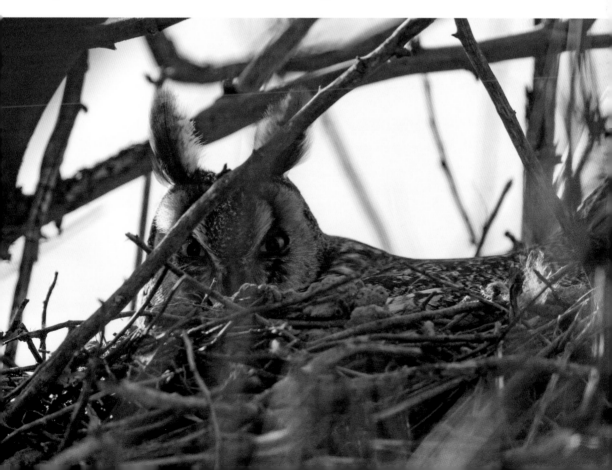

7. Burrowing Owl

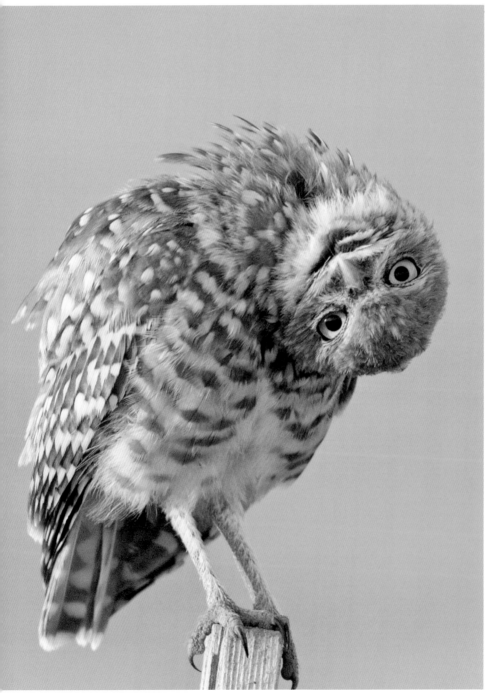

Of all the owls I have photographed over the last twenty years, the burrowing owl is my favorite. First of all, they are very active during the day—unlike most owls. They also have a wonderful habit of turning their heads, which is very endearing and funny. I hope this section of the book will bring a smile to your face.

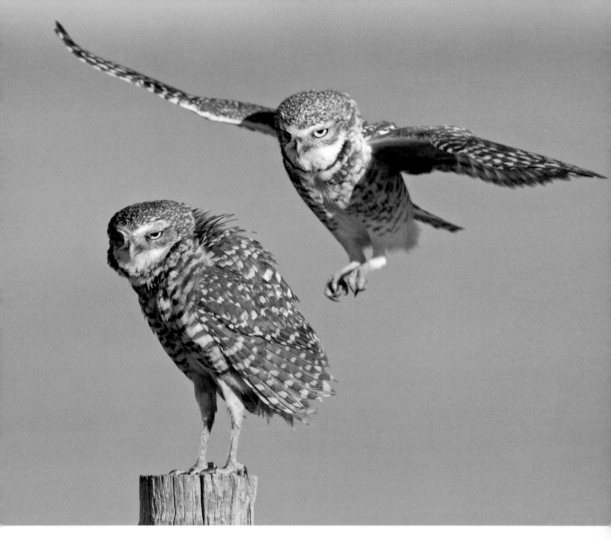

Mating Season

above—During the mating season these little owls seem very aggressive. The incoming male looks as if he is attacking the female.

right—After the attempt at mating, the male accidentally knocked the female off the perch and she fell a couple feet but was saved by the wire attached to the fence.

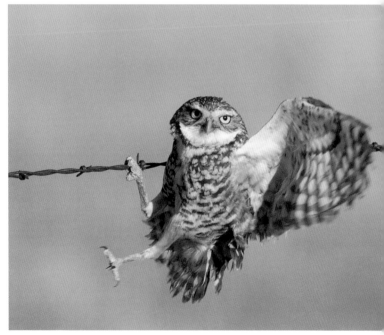

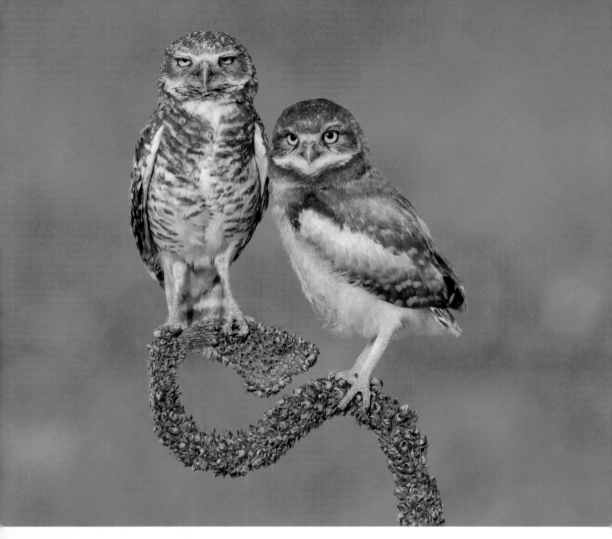

Fledglings

above—It is the fledgling owls that always bring a smile to your face. Here the male owl stands on a mullein plant with a five-week-old youngster.

left—Here is a small family of owls with the adult female and three fledglings.

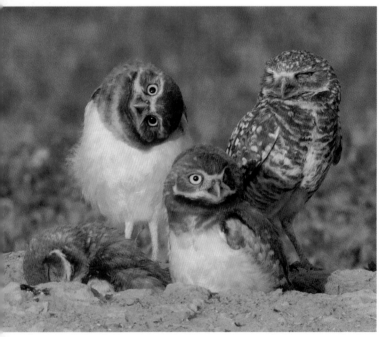

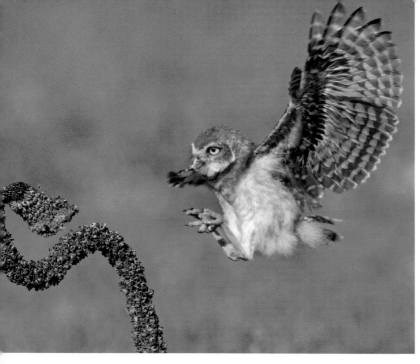

Learning to Fly

left—When the fledgling owls are just learning to fly, finding a good perch is always a good idea. This spot really looked good to one of the owlets as he came in to rest.

below—Crash landings are very common early on.

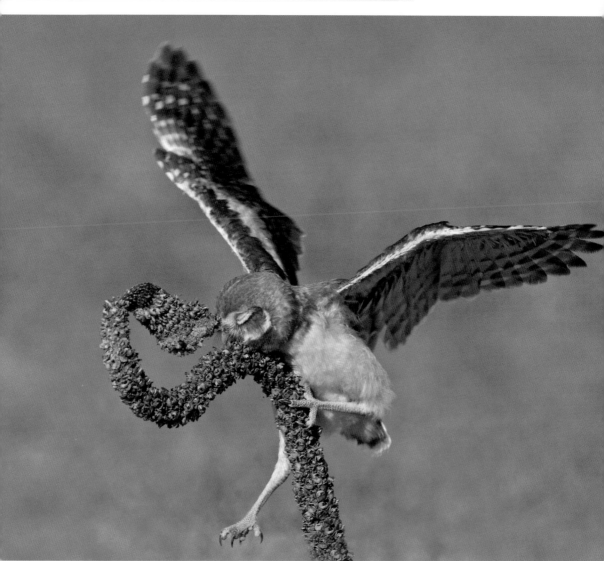

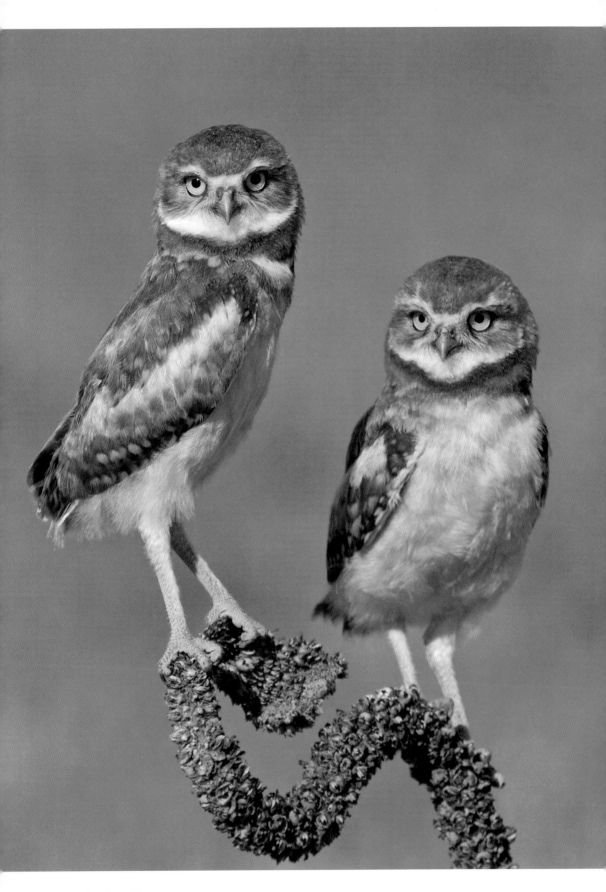

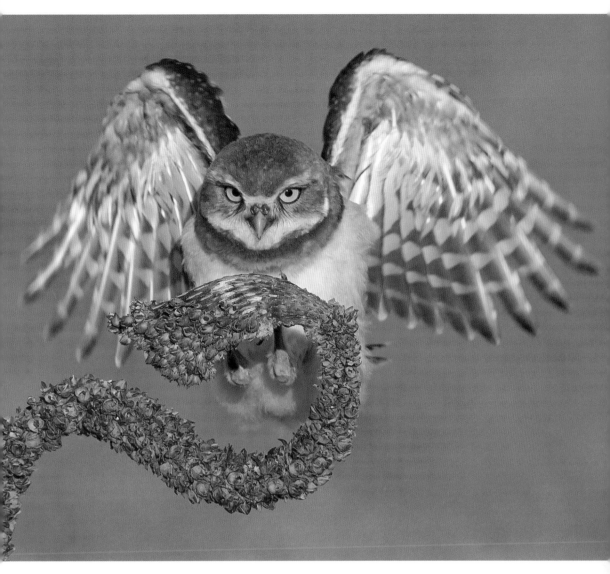

A Better Landing

above—As the owlets get older, they begin to master their flight, and landing on that same mullein (see page 85) is as easy as it gets.

Siblings

facing page—These siblings are very cooperative in sharing their newfound perch. You might think they would be too heavy for such a small perch. Sometimes they are, but this one was able to support the pair of three-ounce birds.

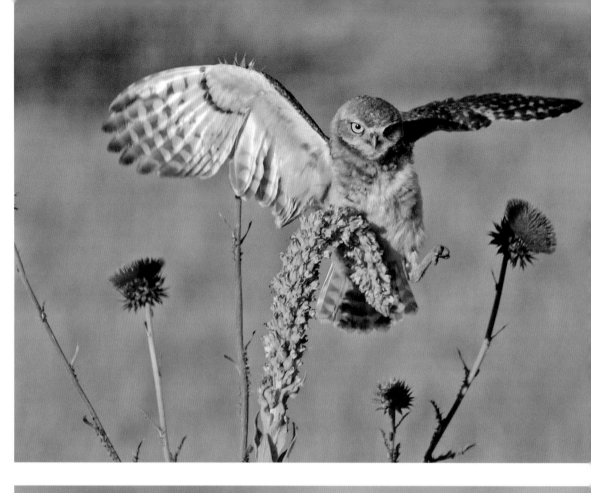
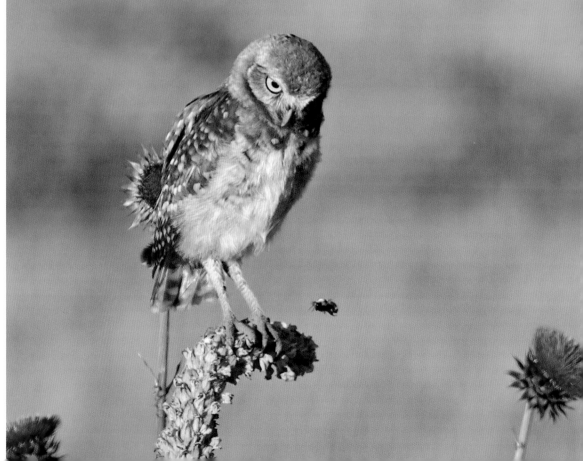

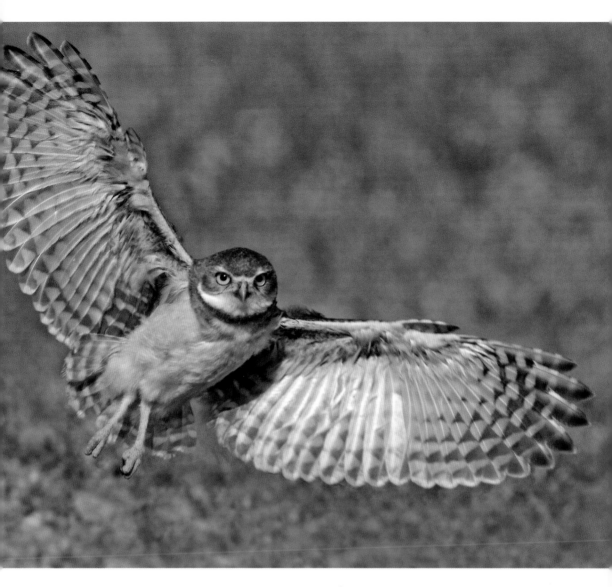

I'm This Big

above—A young owl showing you how big her wings really are.

Young Adventures

facing page, top—Here's a young owl landing on a different perch that was a little less stable.

facing page, bottom—Eventually he stabilizes himself and even has time to watch a bee as it flies by!

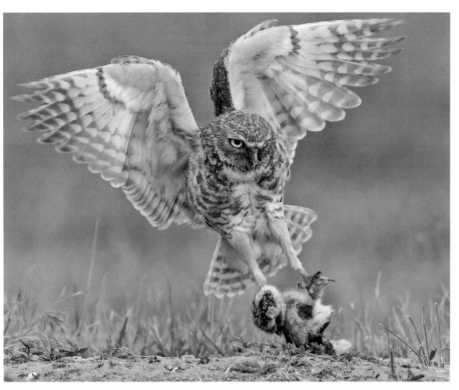

Meal Time

left—The female owl is bringing in some food for the youngsters.

below—The first owlet to get the food is the winner. Here, the young owl is running from his siblings—hoping to eat the little mouse in peace.

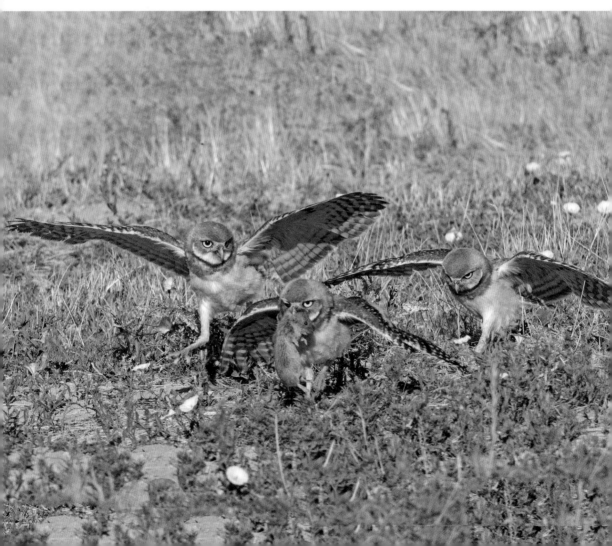

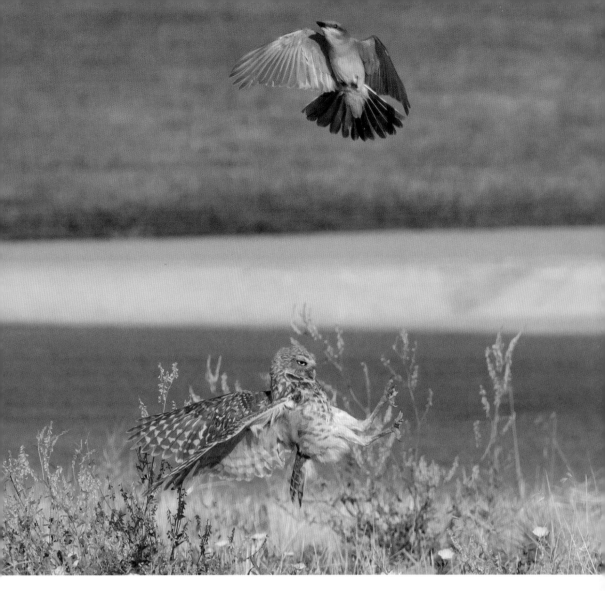

Kingbird vs. Owl

above—Many bird species really don't like owls—probably because owls can and will kill the other species' babies. Here, a western kingbird is harassing this adult owl. The kingbird knows the owl can't catch her, but the owl is still using his feet to attempt to grab the bird.

right—The same kingbird attacking the unaware owl. Note the red patch on the kingbird. This appears only when the bird is in "attack" mode. Neither bird was harmed during the shooting of this photo.

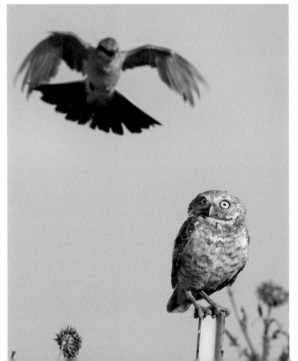

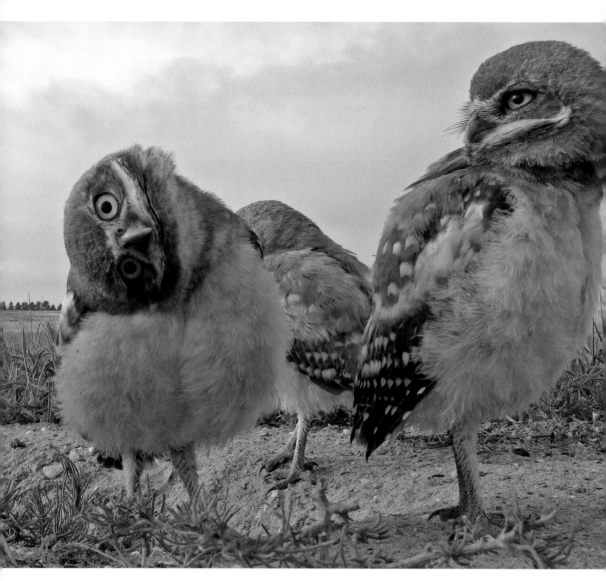

Owl Antics

The antics of burrowing owls really make you wonder what they must be thinking. The owl above appears to be asking, "You again?" The one to the right seems to say, "Gotta stretch my wings!"

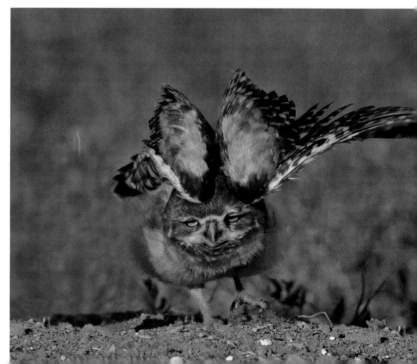

Head Turns

You just have to love the head turns of burrowing owls. Talk about a different way of looking at life!

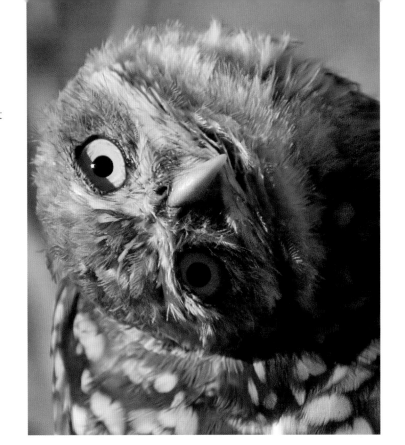

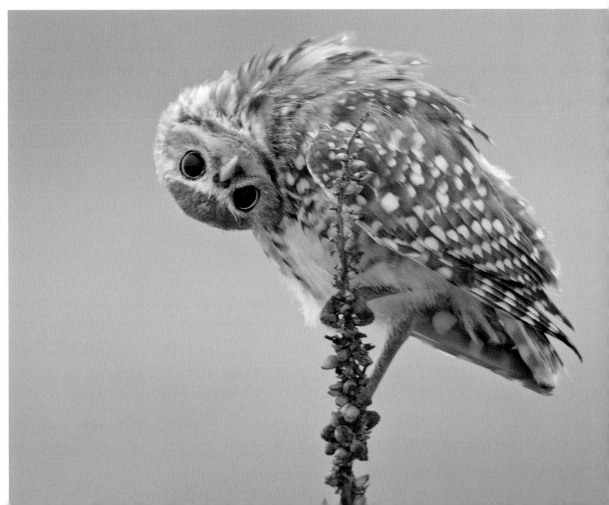

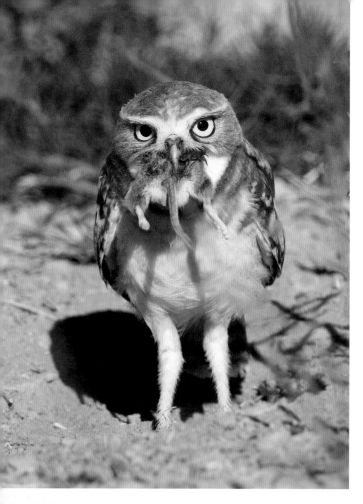

left—This owl landed with quite a big mouthful!

below—You can probably figure out a caption for yourself on this photo. Their postures and expressions seem to say it all!

facing page, top—The owl fluffed up to make himself look larger, trying to scare away a cottontail rabbit that had gotten too close.

facing page, bottom—A young owl amidst the flowers. This photo was taken about ten minutes before the sunrise. The owl's pupils are very big to take in more light.

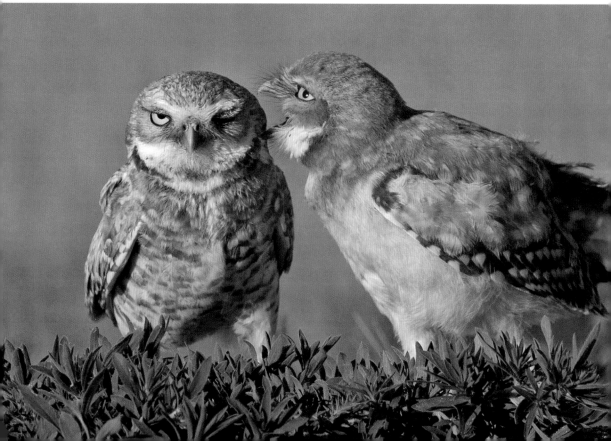

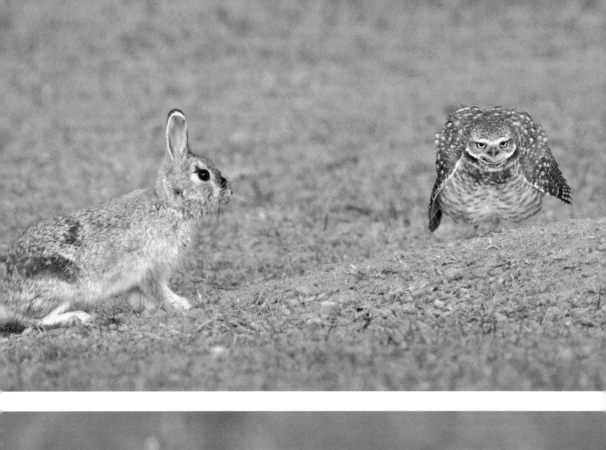
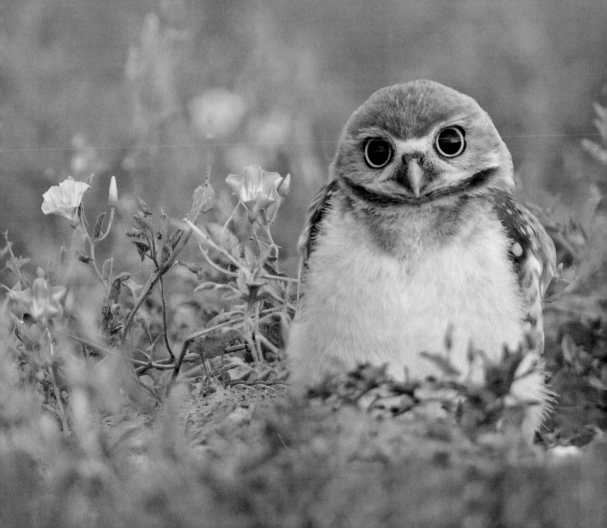

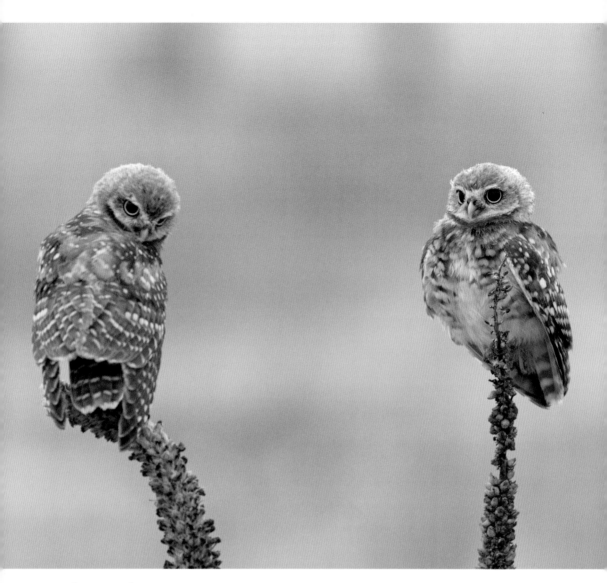

Perching Preferences

above—It should be getting obvious that these owls like to perch on mullein plants. Actually, though, any good perch will do. The area where I found these owls just happened to have a lot of these particular plants around.

facing page—Other owls make for very unstable perches!

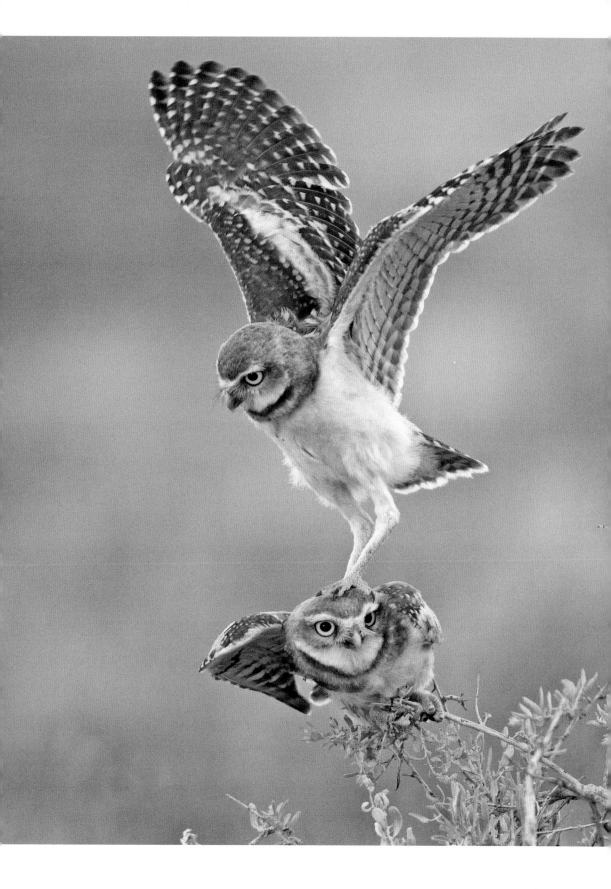

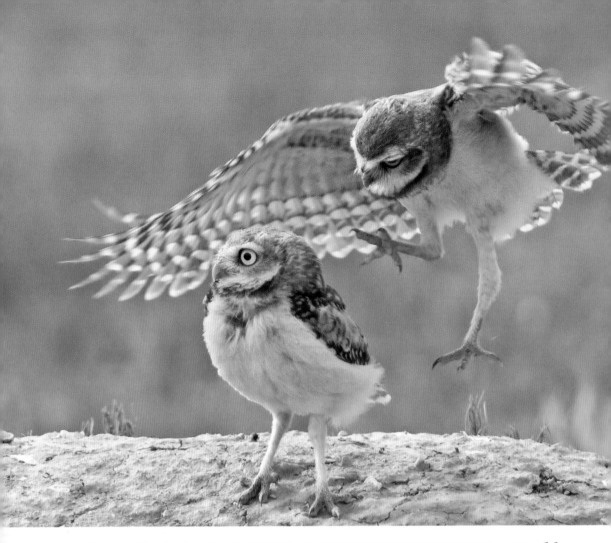

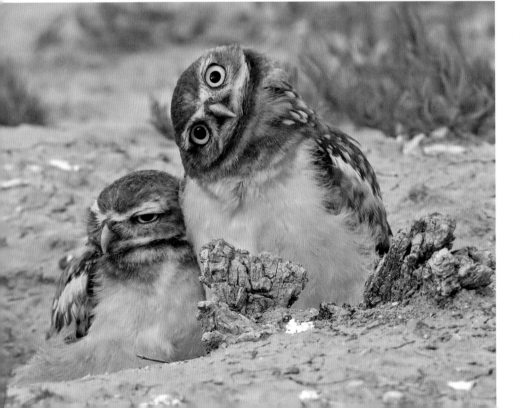

Stealth

above—Sneak attack from behind! This is a pair of young owls doing a mock battle. They did not hurt each other.

A Fresh View

left—People look very different from this angle!

After Sunset

below—This photo was taken after sunset, hence the large pupils.

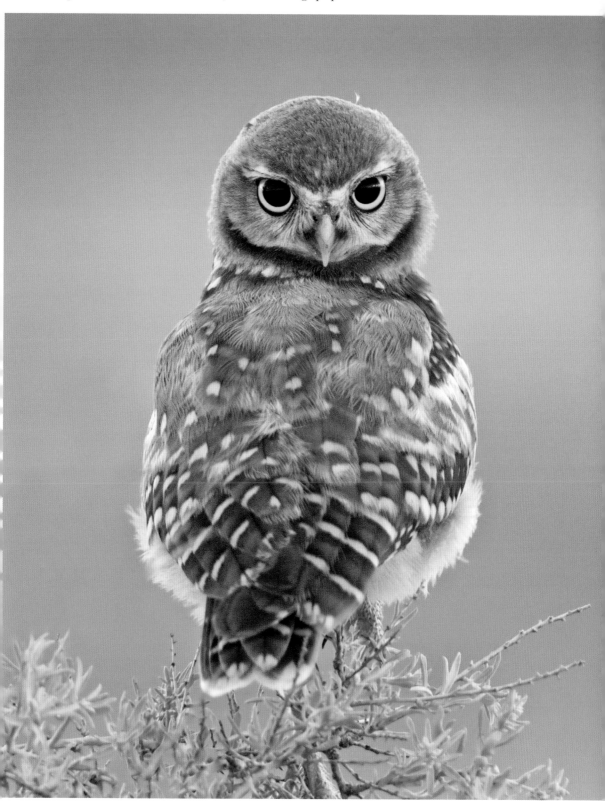

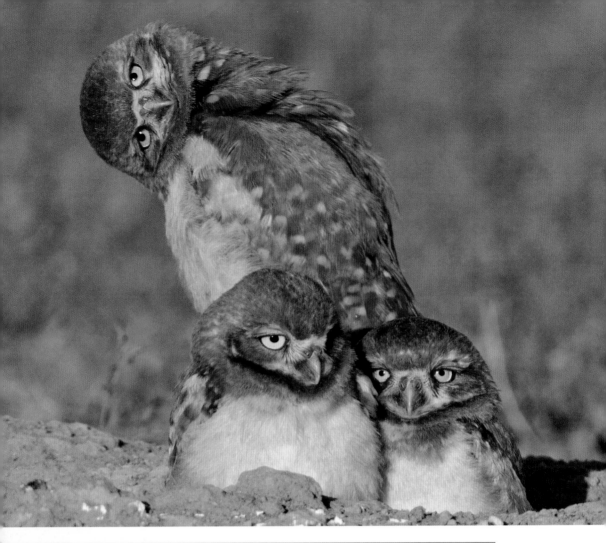

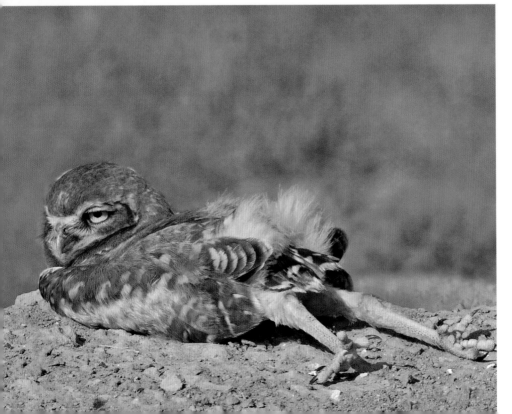

Sunny Days
left—Lazin' on
a sunny
afternoon!

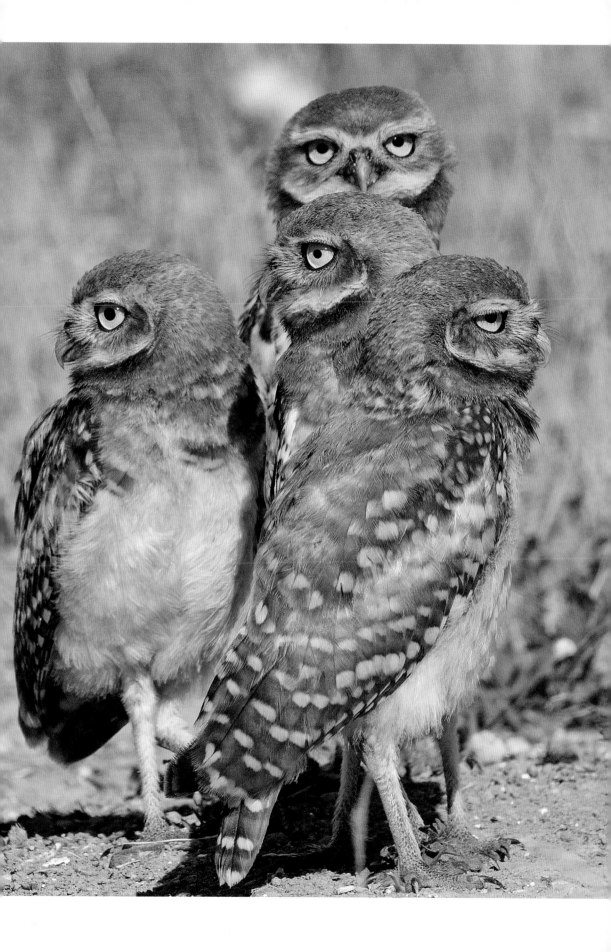

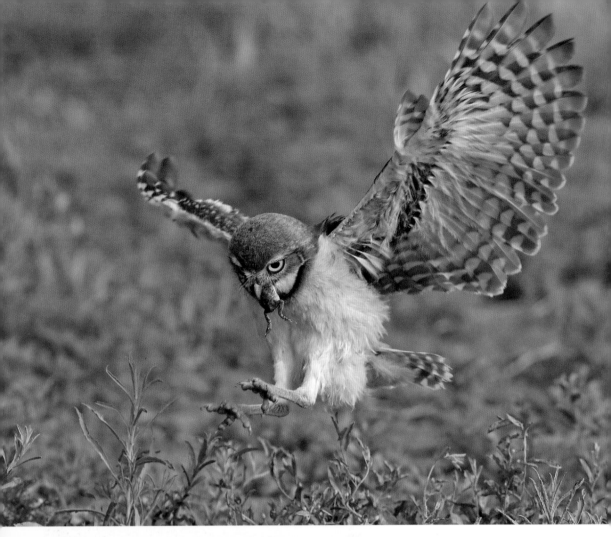

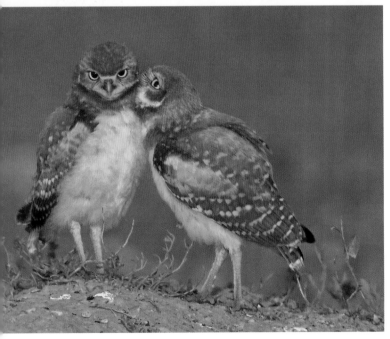

Fresh Catch

above—A young owl landing with a frog in his mouth.

A Private Conversation

left—Two young owlets sharing a secret.

8. Screech Owl

One of the small, nocturnal owls in North America is the screech owl. These owls are a little smaller than pigeons and they usually live in holes in trees built by woodpeckers. They feed on insects and small mammals, such as mice and voles.

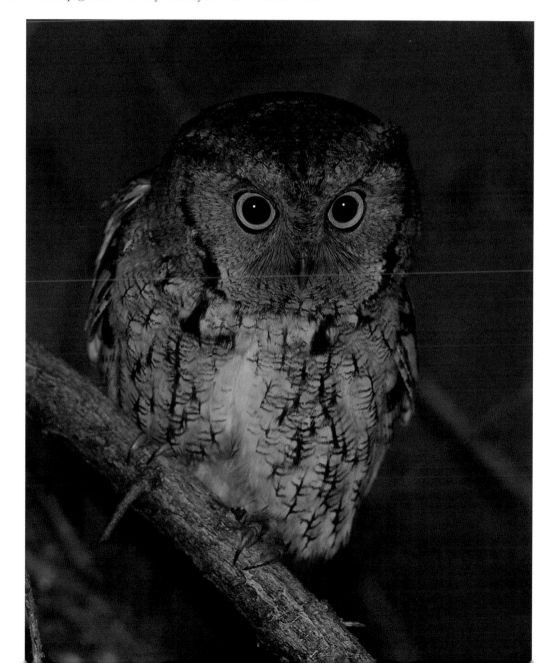

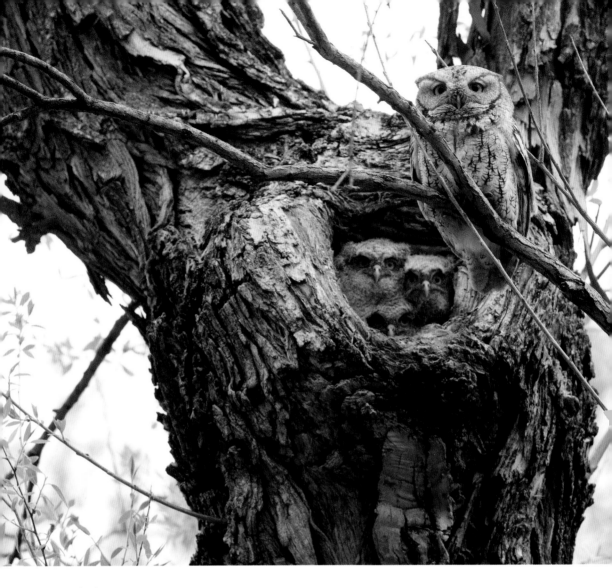

Daylight Hours

above—This is a screech owl nest in a cottonwood tree in Colorado. When you do see these owls during the day, it is usually in the early morning or late evening.

Sweet Faces

facing page, top—Here, one of the owlets is whispering in her mom's ear.

facing page, bottom—The cuteness factor is way up there with this adorable pair!

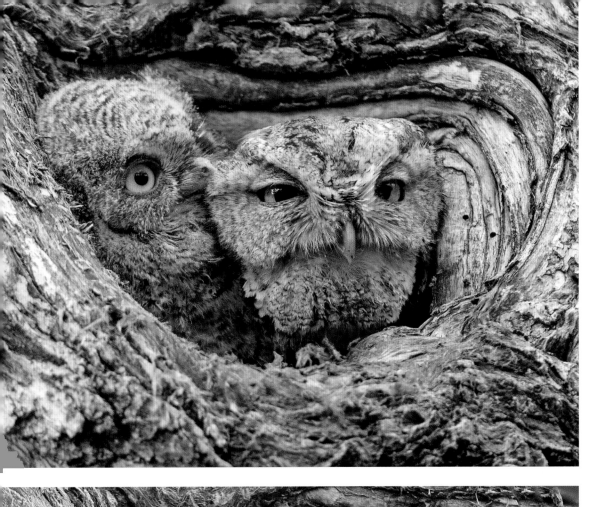

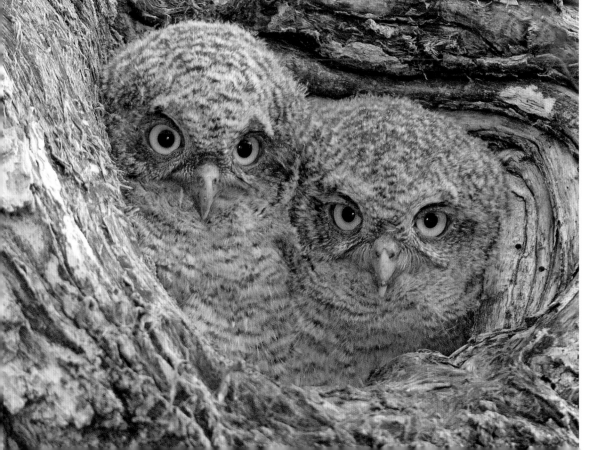

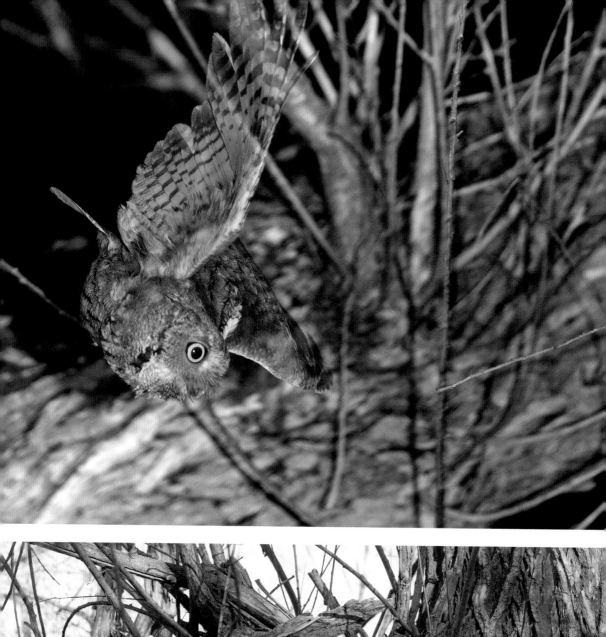
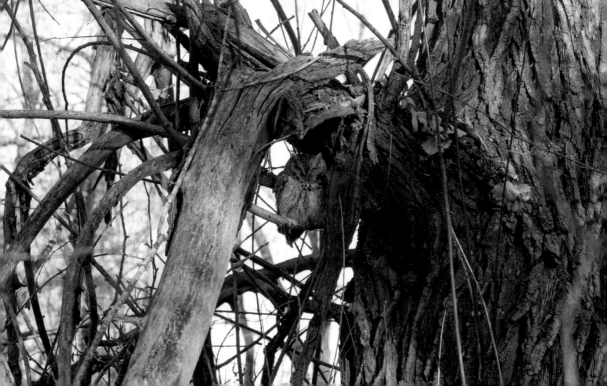

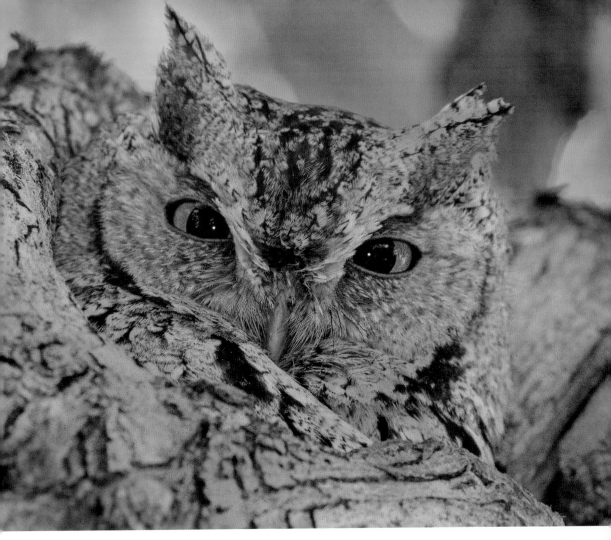

above—This owl was keeping a keen eye on things and seemed to be asking, "What are you doing down there?"

right—A just-fledged owlet.

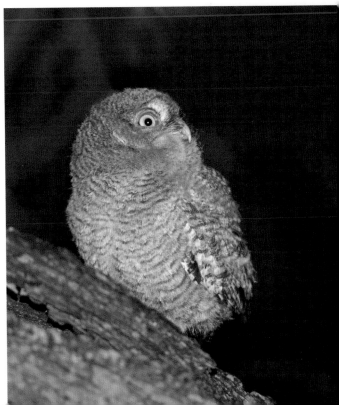

facing page, top—This adult screech owl is diving for its prey.

facing page, bottom—This is a typical day roost for an eastern screech owl.

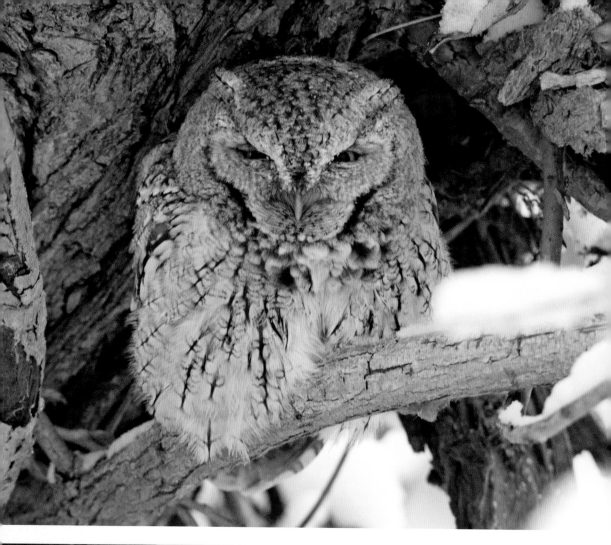

A Cozy Roost

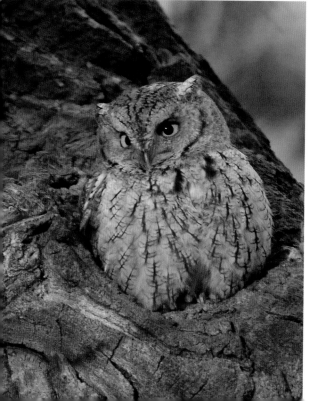

above—During the day, screech owls will sleep in cozy corners of trees without being noticed.

left—Here's one sitting next to her hole just after sunrise. She popped back in her hole seconds later.

right—This is a just-fledged eastern screech owl.

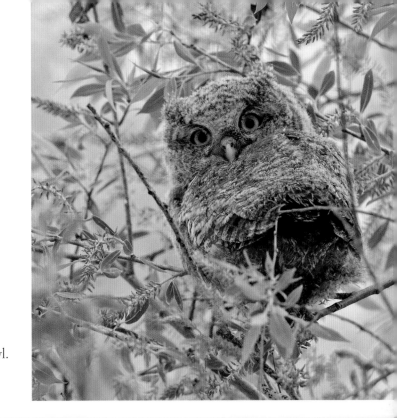

Whiskered Screech Owl

below—This is a whiskered screech owl. They are only found in the Southwestern United States.

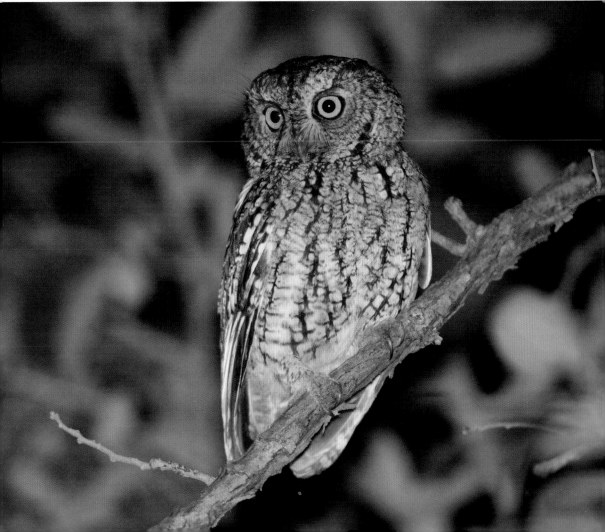

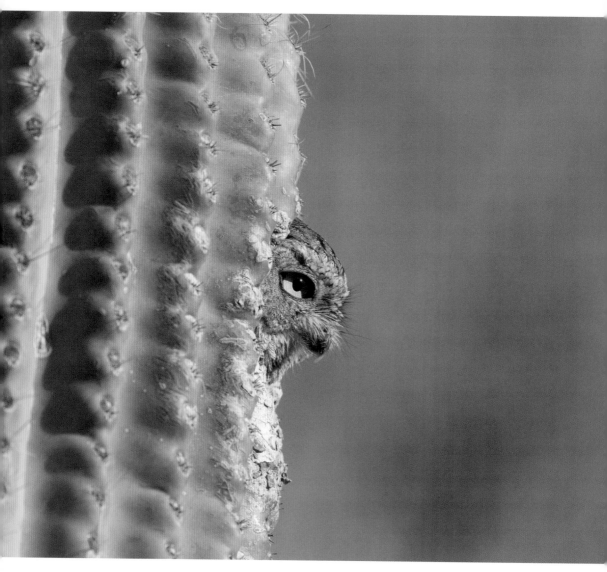

Western Screech Owl

This is a western screech owl. They are found
in the Western United States and they will use
trees and sometimes holes made by woodpeck-
ers in saguaro cacti.

9. Elf Owl

The elf owl is another common owl found in the Southwestern United States. It is the smallest of all the North American owls, standing only about 6 inches tall. This owl chose to nest in an old woodpecker hole in a telephone pole.

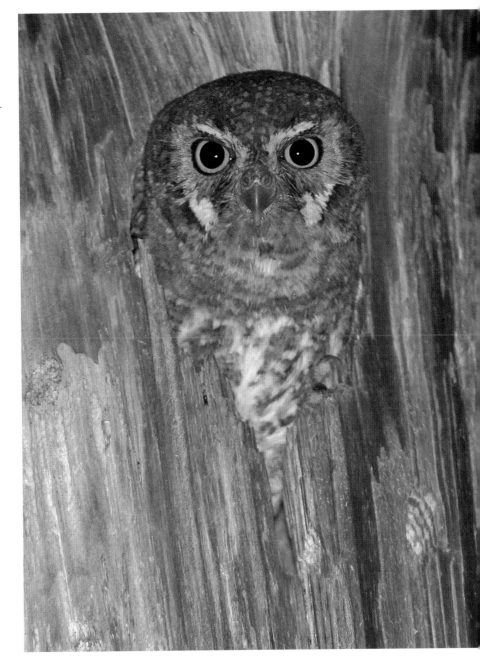

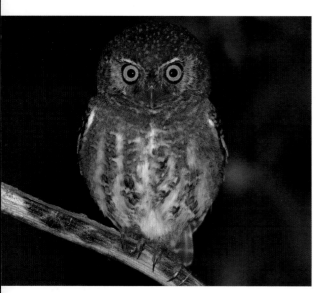

Totally Nocturnal

above and right—Elf owls are totally nocturnal and stay in their holes during the day. They come out at night to feed on insects like beetles and moths.

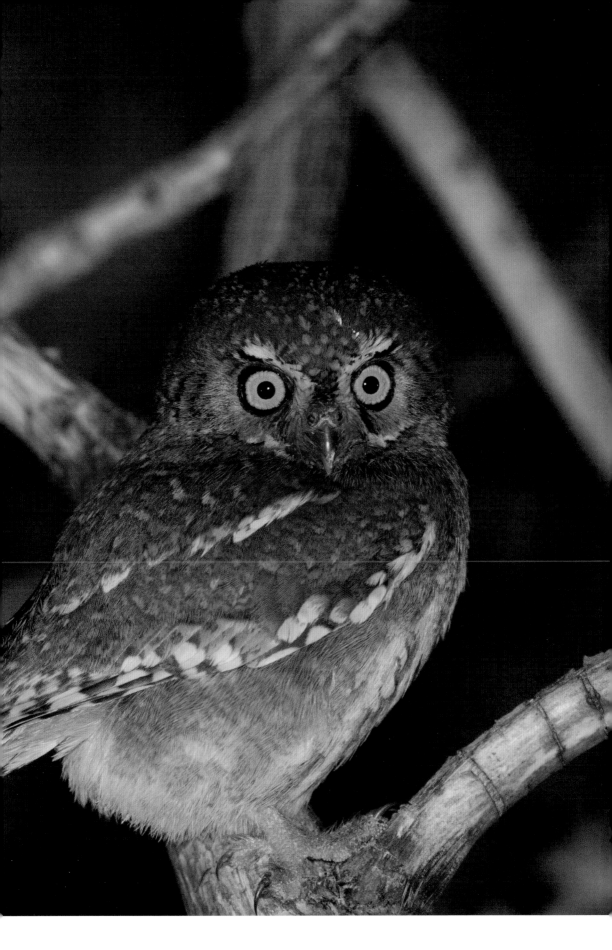

10. Boreal Owl

An owl of the north woods is the boreal owl. This is another small, mostly nocturnal owl.

Lodgepole Pine

below—Here, an adult owl is peering out of its hole in a lodgepole pine. *Photograph by Dan Hartman.*

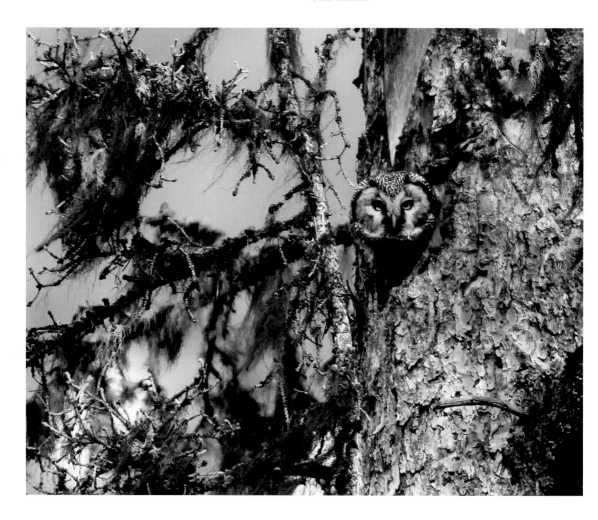

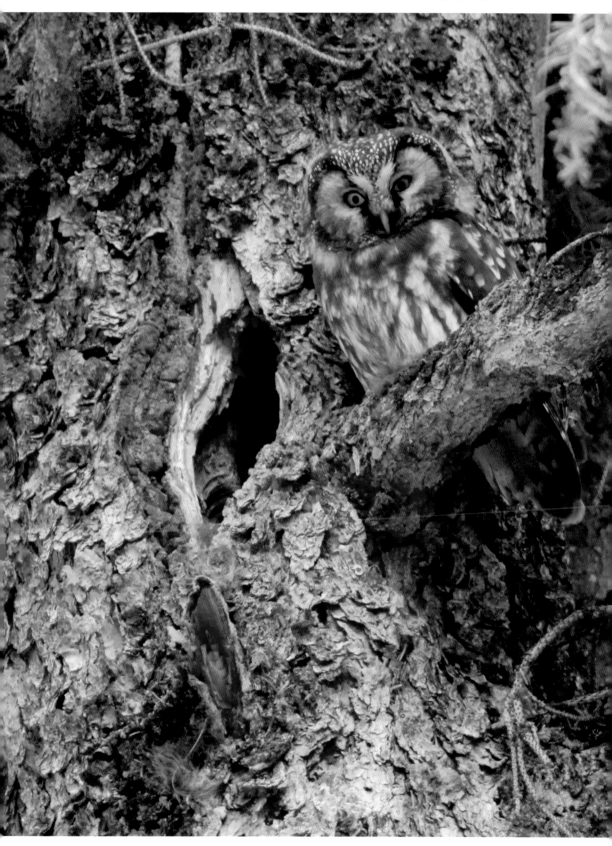

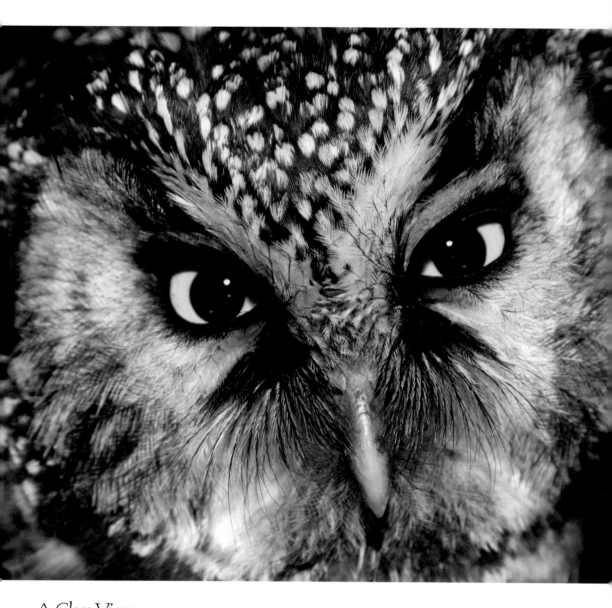

A Close View

This full-face portrait of a boreal owl captures
the intensity of its yellow-eyed gaze. *Photograph
by Dan Hartman.*

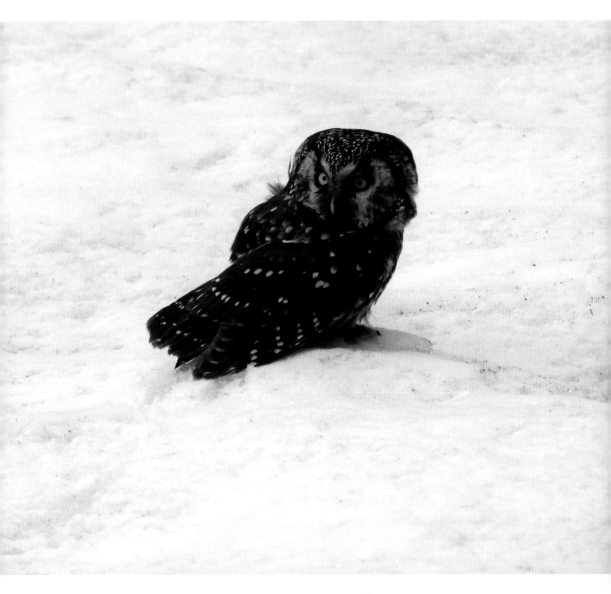

A Rare Photo

This is an unusual image of a boreal owl on the snow during daylight hours. They are typically nocturnal birds. *Photograph by Dan Hartman.*

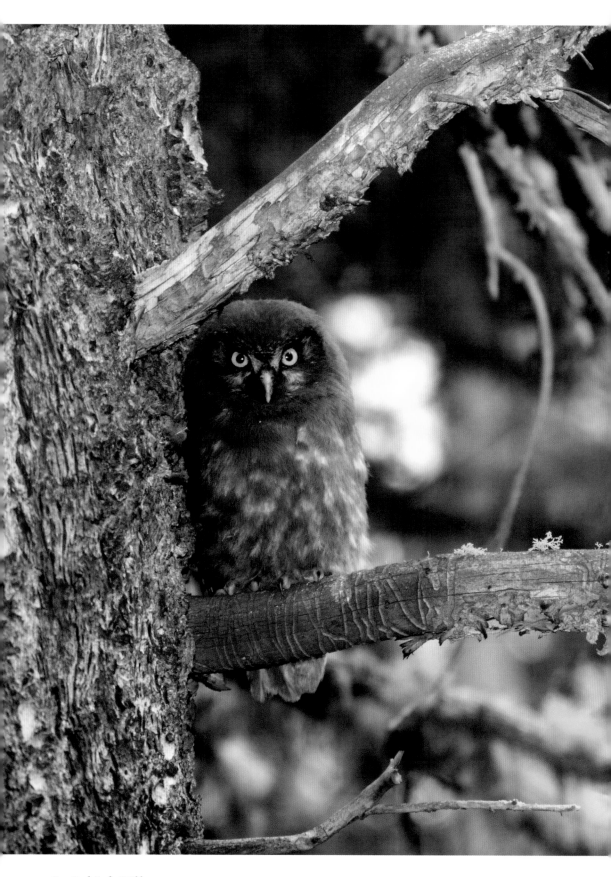

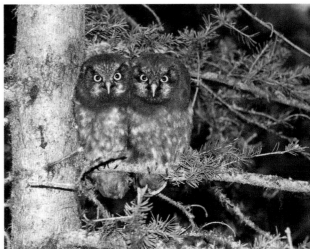

Boreal Chicks

left—A lone boreal owl chick in a pine tree. *Photograph by Dan Hartman.*

above—Two chicks in a pine tree. *Photograph by Dan Hartman.*

II. Pygmy Owl

The smallest diurnal (daytime) owl is the northern pygmy owl.

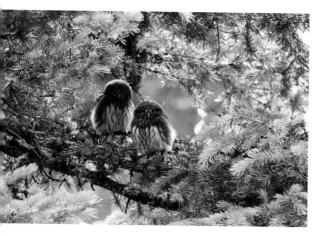

Chicks

left—These two just-fledged pygmy owl chicks were sitting together in a tree. *Photograph by Dan Hartman.*

Food

facing page—Pygmy owls are excellent hunters, but they are so small that few people ever notice them. *Photograph by Dan Hartman.*

below—Here an adult pygmy owl prepares the food he will bring to his brood, nesting in an aspen tree. *Photograph by Dan Hartman.*

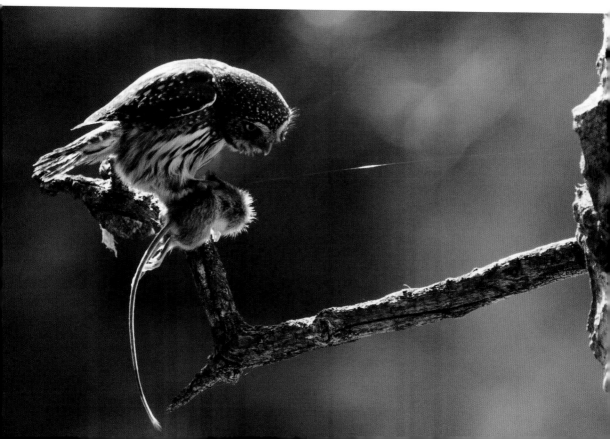

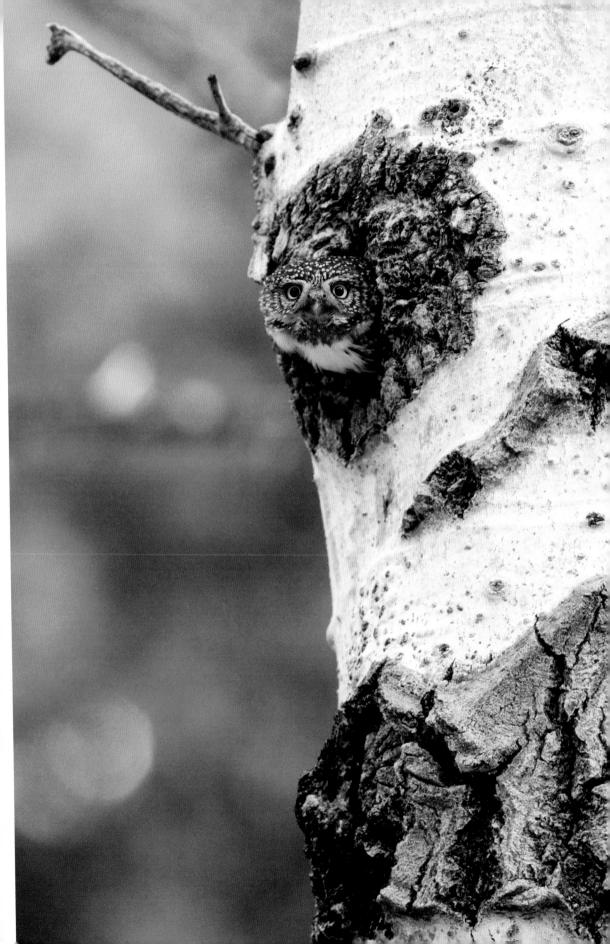

12. Saw-Whet Owl

Another small North American owl is the saw-whet owl. They are also nocturnal and very hard to find.

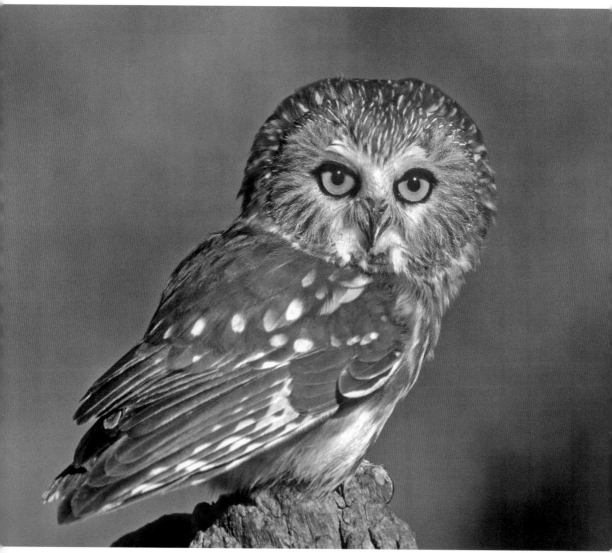

above—A beautiful little saw-whet owl posing during the day. *Photograph by Fi Rust.*

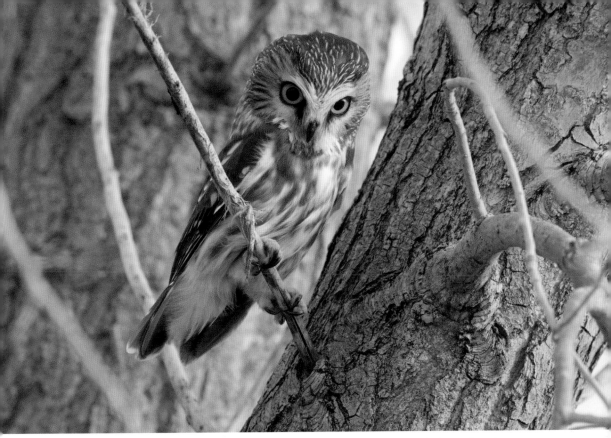

above—When you do find saw-whet owls during the day, you can photograph them for a long time. They don't seem to mind the attention. *Photograph by Blake Hess.*

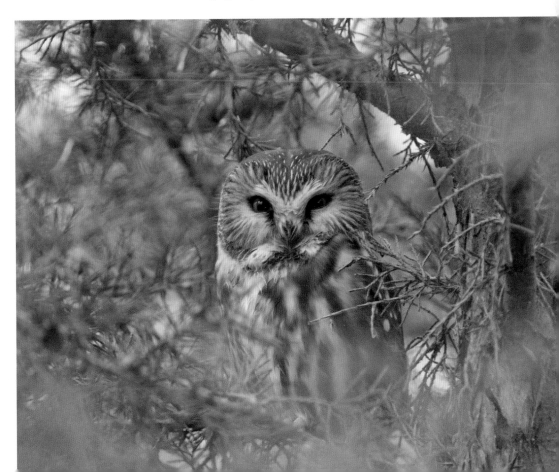

13. Barred Owl

The barred owl is fairly common through much of North America. Almost totally nocturnal, they sometimes are visible near dusk when found near the nest site.

facing page, bottom—This owl was found in a mangrove forest in central Florida.

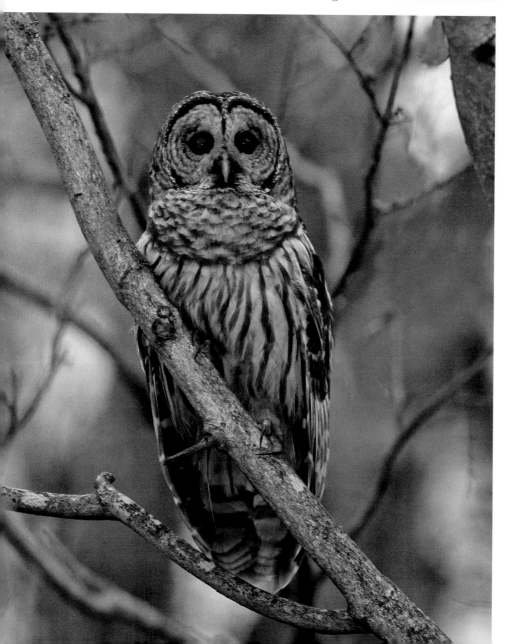

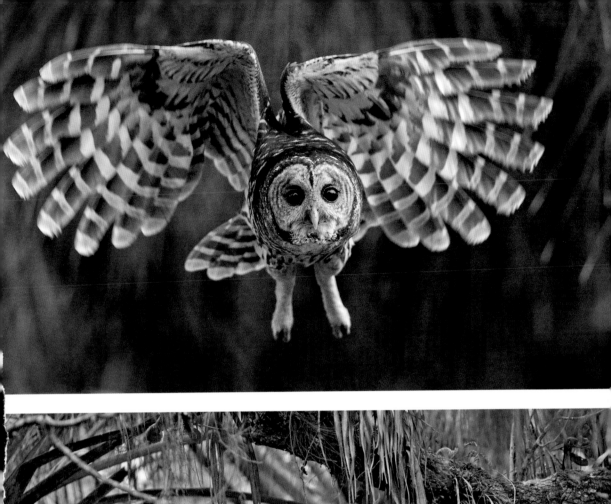
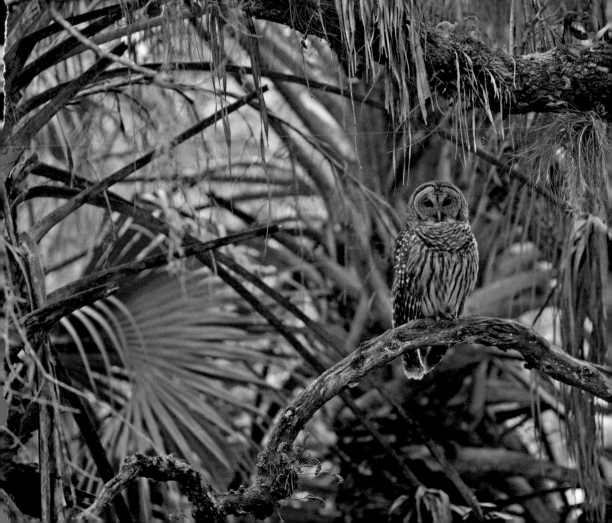

14. Mexican Spotted Owl

These owls are found only in southeastern Arizona and Mexico. They are very uncommon and secretive. I was lucky to find this pair.

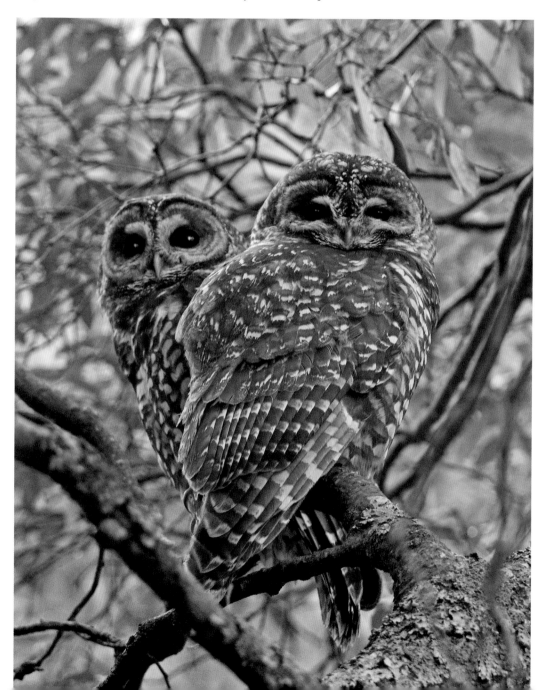

Index